# SURREY'S MILITARY HERITAGE

## Paul Le Messurier

AMBERLEY

First published 2019

Amberley Publishing
The Hill, Stroud
Gloucestershire, GL5 4EP

www.amberley-books.com

Copyright © Paul Le Messurier, 2019

Logo source material courtesy of Gerry van Tonder

The right of Paul Le Messurier to be identified as the
Author of this work has been asserted in accordance
with the Copyrights, Designs and Patents Act 1988.

ISBN  978 1 4456 8962 3 (print)
ISBN  978 1 4456 8963 0 (ebook)

British Library Cataloguing in Publication Data.
A catalogue record for this book is available from the
British Library.

Origination by Amberley Publishing.
Printed in Great Britain.

# Contents

# Introduction

Surrey, known for its commuter towns, leafy suburbs and rolling hills, has not always been the peaceful haven that it might appear today. Located immediately to the south of London, between the capital and the English Channel, the county has often been at the forefront of armed conflicts throughout the centuries.

In the early days the south of Surrey, known as the Weald, was an area of swamps and forest, mainly uninhabited, that made it a difficult terrain for invading armies. Yet this did not prevent Roman, Viking and Norman invaders from leaving their mark on the county. Then there are the Surrey Hills, part of the North Downs, a natural barrier between the coast and the capital city, on which defences were built in times of need. Evidence of ancient hilltop forts, Norman castles, Victorian forts and Second World War defence lines can still be found there. The proximity to the south coast and the plentiful open spaces meant that Surrey has often been home to military camps, especially in Victorian times and during both world wars.

As the Battle of Britain unfolded in the skies over Surrey, the airfields of the county rose to the occasion against the might of the German Luftwaffe. Brooklands, near Weybridge, became a major design and manufacturing centre during the early days of wartime aviation. Two of the Second World War's most iconic aircraft, the Hurricane and Wellington, were manufactured there.

The boundaries of the county have changed somewhat over time. Originally, Surrey included areas that are now part of London, such as Southwark. The 1960s saw the loss of Kingston upon Thames to Greater London compensated for by the addition of Staines from Middlesex. Gatwick belonged to Surrey until 1974 when it became part of West Sussex.

From Staines in the north to Haslemere in the south, from Farnham in the west to Caterham in the east, this book provides a fascinating insight into the events, people and places that make up Surrey's military heritage.

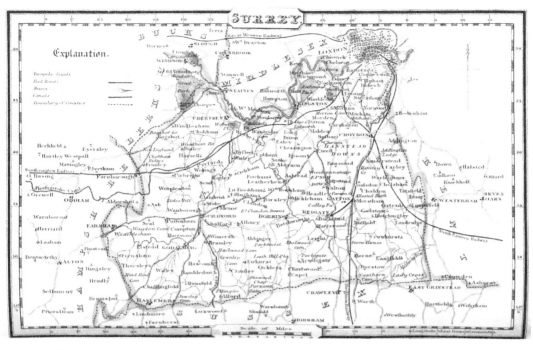

Map of Surrey *c.* 1842.

# 1. Romans and Anglo-Saxons

In 55 BC a Roman army, led by Julius Caesar, landed in Kent. Caesar's mission was most likely one of reconnaissance rather than conquest. In any event, his army, faced by local tribes, was unable to move far inland. Caesar returned with a larger force the following year. This time he marched through the area that is now known as Surrey along the ancient road on the North Downs, heading towards the Thames. Caesar eventually withdrew back to the Continent to subdue the troublesome people of Gaul.

One hundred years later, the Roman conquest of Britain began under Claudius. In AD 43, a Roman army of around 40,000 men defeated the Britons in several battles as they made their way through the south-east. It was not long before the south of Britain became part of the Roman Empire. The British hill forts that existed at the time were used for defensive purposes and for protection of the local population during times of war. In Surrey, remains of hill forts have been found at St George's Hill near Weybridge, Anstiebury, Hascombe, Holmbury Hill and at War Coppice near Caterham. Some hill forts were occupied by Roman forces while many fell into disuse.

The Romans established the town of Staines, north-west Surrey, most probably as a military base. Known in those times as 'Pontes', it was an important crossing point over the River Thames. The bridge at Staines carried one of the principal roads linking London and the old Roman town of Silchester in Hampshire. Other roadside settlements during Roman times were at Ewell and possibly one at Dorking. Excavations in Surrey have uncovered a Roman villa and bathhouse in Ashtead and a villa at Walton Heath. Two Romano-Celtic temples have been found at Wanborough, west of Guildford and at Farley Heath.

Soon after the invasion, the Romans began the construction of a series of roads connecting the most important sites. Built by the Roman legions for moving the army around quickly, these roads soon became important communication and trading routes between principle towns.

The main Roman road through Surrey ran from Chichester to Southwark. The road, Stane Street, went through Ockley then past Dorking. Crossing the River Mole at Burford Bridge, it continued up to Mickleham Downs and on towards Ewell. Stretches of the A24 road closely follow the original route. A Roman road ran through Godstone while another from Winchester to London passed near to Farnham and Chertsey. These roads would have had resting stations at regular intervals.

The Romans, facing a growing threat back home, finally withdrew from Britain in AD 410. As Roman rule began to subside, Angles and Saxons from Germany and Jutes from Denmark arrived in southern and eastern Britain, some possibly brought in as mercenaries. Over time, several distinct Anglo-Saxon kingdoms – such as East Anglia, Essex, Kent, Mercia, Sussex and Wessex – were formed.

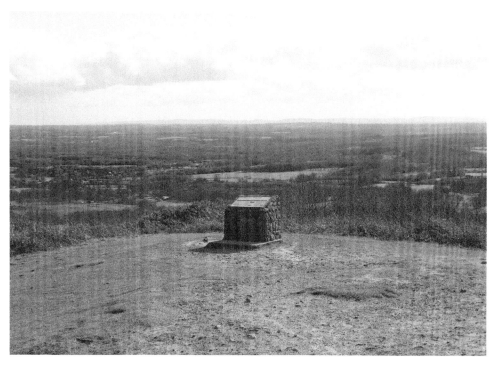

Commanding views from Holmbury Hill Fort towards the south coast.

Outline of the walls of the Romano-Celtic temple at Farley Heath.

The Roman road, Stane Street, between Mickleham and Ewell.

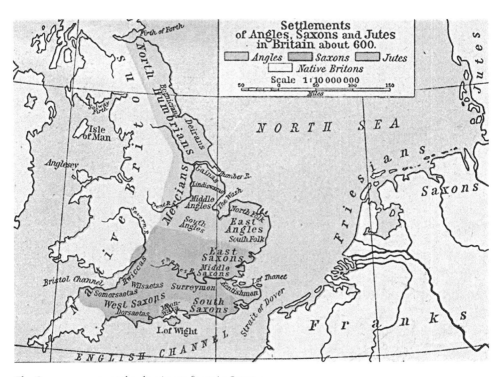

The Saxons were once the dominant force in Surrey.

The name Surrey originates from the Saxon name 'Sutherge', meaning southern district or region. Surrey was never a separate kingdom during the Anglo-Saxon period but remained a prized and fought over possession among the different kingdoms, mainly because of its location on the boundaries of Wessex, Sussex and Kent. In 568, the West Saxons defeated an army from Kent, most probably at Wimbledon, and Surrey became part of Wessex.

Wessex remained the dominant power in the south of England for almost a century until the Mercians overpowered the West Saxons and made their way through Surrey as far as the Isle of Wight. During this time, Wulfhere, the King of Mercia established an abbey at Chertsey in 666, the first of its kind in Surrey. It was not until 825 that Surrey reverted to Wessex rule after Egbert, King of the West Saxons, had defeated the Mercians. The Anglo-Saxons were soon to face a violent, destructive force from across the sea.

In 851, a fleet of 350 Viking ships landed on the Thames Estuary. They sacked Canterbury before moving on to London, defeating Beorhtwulf, King of Mercia, and his army. They then proceeded across the Thames into Surrey heading south along the Roman road, Stane Street. The intention was to meet up with their ships on the south coast before advancing towards Winchester, then the base of King Ethelwulf of Wessex.

It was on their way south that they encountered Ethelwulf, with his son Ethelbald, at Ockley. The night before the battle, the Vikings rested at Anstiebury, the old, disused British camp. On the following day a violent encounter ensued above Ockley on the slopes of Leith Hill during which the Vikings were crushed. The ferocity of the battle is graphically illustrated in the Anglo-Saxon Chronicle, which reports that Ethelwulf 'made the greatest slaughter of the heathen army that we have ever heard reported to this present day'.

Viking military tactics were based on flexibility and speed. They would attack, loot and withdraw before the Anglo-Saxon armies had time to mobilise, often targeting monasteries and churches. Chertsey Abbey was raided on several occasions. In 871, the abbot and ninety monks were massacred and the main church burned down. A tenth-century, double-edged, iron Viking sword was uncovered in 1981 not far away and is on display in Chertsey Museum.

Following Alfred's defeat of the Viking army in 878 at the Battle of Edington in Wiltshire, he began to reorganise the defence of his realm based on a system of fortifications called 'burhs'. He built thirty-three in total throughout the kingdom of Wessex, placed at equal distances, enabling his troops to reach a potential attack in one day.

The only 'burh' in the county of Surrey as we know it today was established at Eashing, near Godalming, on steeply sloping ground. On the eastern bank overlooking the River Wey, the stronghold provided protection for the river crossing there. It was the responsibility of the men in the surrounding area to defend the fortification and a system for calculating the number of men required for each 'burh' was determined. In the case of Eashing, this would have been around 600 men.

In 893, 250 Viking ships landed on the Kent coast and set up a base just inland at Appledore. The following year the Viking army headed west through Surrey, plundering as they went. It was at Farnham that they were defeated by Edward, eldest son of Alfred the Great, who recovered the Viking's ill-gotten gains and forced them northwards out of Surrey.

The remains of Chertsey Abbey.

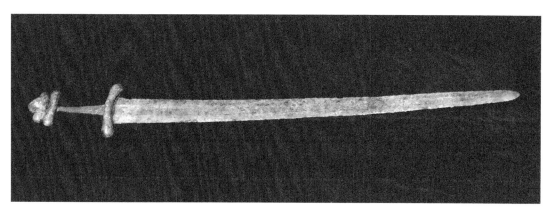

Viking sword found near Chertsey. (Courtesy of Chertsey Museum, copyright Brian Wood)

Whereas the earlier Viking incursions were mainly for the purpose of looting, the next was with the intention of conquest. In 1013, Sweyn Forkbeard landed and quickly took control of England in just a few months. The Anglo-Saxon king, Ethelred the Unready, fled to Normandy. Sweyn died in 1014, at which time the Anglo-Saxons reclaimed England with the return of Ethelred. The Vikings were not to be outdone. In 1015, Sweyn's son, Cnut, landed in Wessex and after several ferocious encounters overcame the Anglo-Saxon army to become King of England. He would rule for nineteen relatively prosperous and peaceful years.

The death of King Cnut in November 1035 was to result in a brutal massacre at Guildford that would have far-reaching consequences. There were now four claimants to the throne. Harold Harefoot and Harthacnut were the sons of Cnut. Edward and Alfred, in exile in Normandy, were the sons of Ethelred.

Alfred returned from exile together with a guard of 600 Norman mercenaries, supposedly to visit his mother at Winchester. He landed on the south coast and was making his way inland when he was met and befriended by Earl Godwin of Wessex and taken to Guildford. Godwin found accommodation for Alfred in the town, promising to escort him to London to claim the throne. In fact, Godwin was a loyal supporter of Harold Harefoot, who had by then become King of England.

The following day, Godwin took Alfred to Guildown, now known as Hog's Back, where the majority of Alfred's Norman guards were mercilessly slaughtered. The remains of over 200 bodies discovered at an Anglo-Saxon burial site near Guildown Avenue in Guildford are thought to be those of Alfred's massacred guards. Alfred was taken hostage and conveyed to the monastery at Ely. His eyes were removed. Cared for by monks, he died from his injuries in early 1036. The Normans were to take their revenge thirty years later.

# 2. The Norman Conquest

Edward the Confessor became king in 1042, having spent the majority of his life in exile in Normandy. On his death in January 1066, Harold was crowned King of England. Harold was the son of Earl Godwin, the perpetrator of the massacre at Guildford that had resulted in the untimely death of Alfred, Edward's brother. Harold, however, had a rival in William of Normandy who claimed he had been promised the throne by Edward. William prepared to invade England and landed at Pevensey in East Sussex in September 1066.

After William had defeated Harold Godwinson at the Battle of Hastings, he made the coasts of Sussex and Kent secure and then turned in a north-west direction towards London, keeping south of the River Thames. William's main army headed towards Southwark, at that time in Surrey. He failed to take the bridge at Southwark and, unable to cross into London, he left the area in ruins.

Before reaching Southwark, a group had split off from the main army and proceeded via Westerham into east Surrey and along the Pilgrim's Way towards Winchester. They continued through Limpsfield, Godstone, Bletchingley, Merstham and Gatton. The armies left a trail of destruction along the route, only sparing the lands of Edward the Confessor's widow, Queen Edith, at Reigate, Dorking and Shere.

From Southwark, William headed south along the Roman road, Stane Street, and met up with the rest of his army near Dorking. From there they continued on towards Winchester, then crossed the Thames at Wallingford before accepting the surrender of the English at Berkhamsted.

The building of castles was the principal way in which the Normans attempted to control the land they had recently conquered. William, according to the Anglo-Saxon Chronicle, 'wrought castles widely through this country, and harassed the miserable people'. These castles were simple in nature and built quickly, mostly of the motte (mound) and bailey (courtyard) design. The mound was usually created by piling up earth and leaving a surrounding ditch or moat, although some made use of natural hills.

Guildford Castle was built shortly after the conquest in 1066, probably by William himself, as one of a series of fortifications around London. By then Guildford had become the predominant town in the county with approximately 400 inhabitants, located along the main route between London and the south. Constructed on the edge of town, the original castle structure would have consisted of a wooden tower on top of the mound with a wooden fence surrounding the courtyard below. The wooden tower was replaced by a square stone keep in the twelfth century. Originally established for military purposes, the castle became the county prison, then a palace after Henry III had made significant improvements in the thirteenth century.

William divided up the land and granted ownership to trusted Norman barons who had fought with him at Hastings. They were encouraged to construct castles to protect

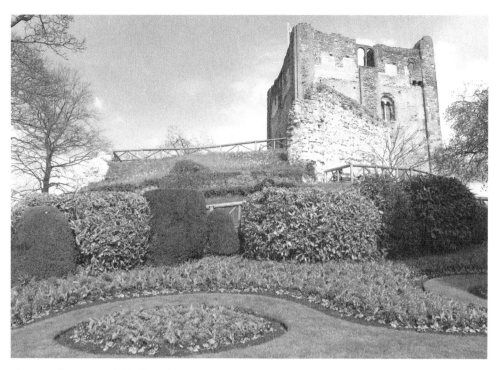

The stone keep at Guildford Castle.

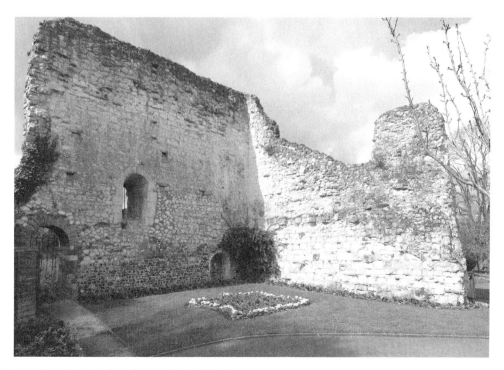

Remains of the Castle Palace walls, Guildford.

The Castle Arch, Guildford.

their possessions and support William in defeating the frequent rebellions that afflicted his reign.

Richard FitzGilbert, a cousin of William, received extensive lands in many counties, including thirty-eight manors in Surrey. Within twenty years of the invasion, Richard was the largest landholder in Surrey after William himself. Richard's lands spanned from Southwark to Ockley and from the Kent border to Shalford, south of Guildford. It was at Bletchingley, between Redhill and Godstone, that he built one of his castles that became the principal family seat. Only the earthworks and foundations remain today. Richard also built Betchworth Castle, east of Dorking.

Another of the Norman lords who had fought at Hastings, William de Warenne, was also given land in the county and became the Earl of Surrey. His son, the 2nd Earl of Surrey, built Reigate Castle in the 1080s on a natural hill surrounded by a dry moat. The original wooden construction was replaced by stone buildings and the castle extended with the addition of an outer bailey in the thirteenth century. A Norman motte castle was erected at Abinger.

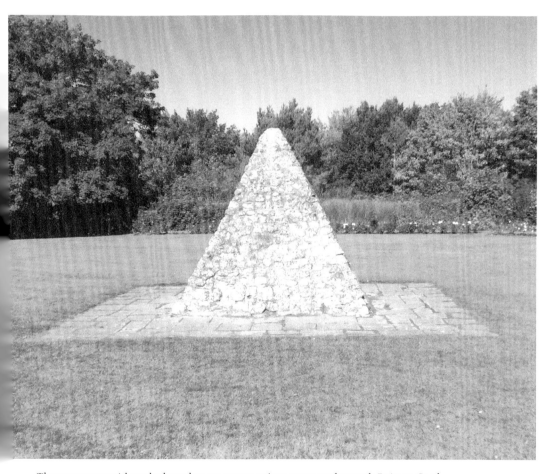

The stone pyramid on the keep has an entrance into caves underneath Reigate Castle.

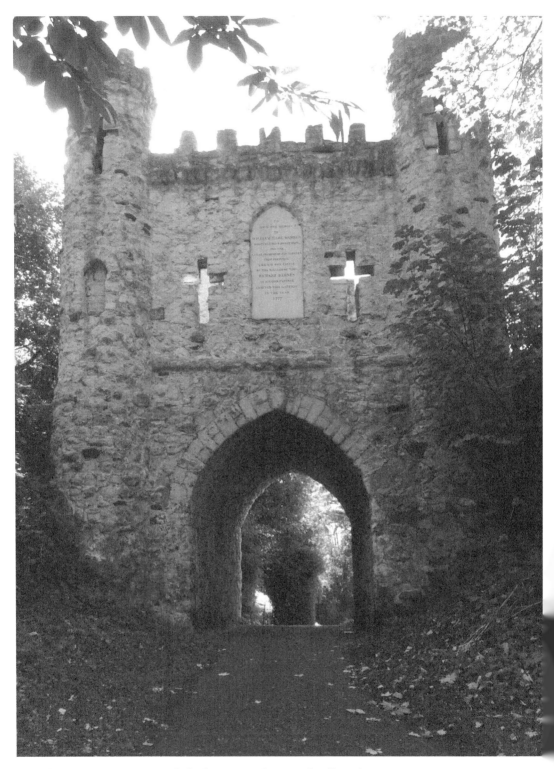

The gateway to Reigate Castle, built in 1777 in honour of William de Warenne.

Farnham Castle was built in the 1130s by Henry de Blois, the Bishop of Winchester, consisting of a tower on a natural earth mound. The early tower was demolished soon after and a shell keep and stone wall added in the early thirteenth century.

The castles of Surrey were subjected to a French invasion during the First Barons' War. Following an attempt by King John to annul the Magna Carta in 1216, a group of rebel barons invited Prince Louis of France to help them overthrow the king. Louis landed on the Kent coast with an army and set off towards Winchester. He stopped off at Bletchingley before occupying the castles at Reigate, Guildford and Farnham, in effect taking control of Surrey.

King John died in October 1216, at which the rebel barons pledged their support for the new king, Henry III. The French were defeated at Lincoln and Sandwich, and the Surrey castles were vacated when Prince Louis sought peace and returned to France in 1217. Farnham Castle would go on to be central to the action during the English Civil War.

# 3. English Civil War

Under cover of darkness on 10 January 1642, Charles I fled with his family from Westminster to seek refuge at Hampton Court. He had tried to arrest five members of the House of Commons for treason. Forewarned, the MPs had found safety in the City of London. Sensing growing opposition, the king left the capital.

The conflict between Charles and Parliament had developed over a number of years, fuelled by disagreements over religion and taxes. Charles believed in the divine right of kings while Parliament attempted to restrict his powers. The relationship deteriorated to such an extent that Charles went on to formally declare war on Parliament in August 1642.

Like most counties in the south-east, Surrey supported Parliament, although there were small pockets of Royalists throughout the county. Sir Richard Onslow, MP for Surrey, raised a regiment made up mostly of local gentlemen to secure the county for the Parliamentarians. Surrey was a significant acquisition since it contained the most important gunpowder mills in the land at Chilworth, south of Guildford, established by the East India Company in 1626. The mills, powered by the River Tillingbourne, became a major source of gunpowder for Parliamentary forces. The mills would continue to ply their trade for another 300 years, closing down in 1920.

Farnham Castle would change hands on several occasions between the Parliamentarians and Royalists. Protecting the road leading from London to Winchester, Southampton and Portsmouth, Farnham became a garrison. On 14 October 1642, the poet George Wither was made Governor of Farnham Castle by a Parliamentary committee and set about reinforcing the battlements. Yet he only had two squadrons with limited armaments and stores. His men patrolled the roads running through Farnham, at the same time keeping a close watch on the townsfolk, some of whom remained loyal to the Royalist cause.

By October, the king had occupied Oxford and the following month set out along the Thames towards London. In November, Prince Rupert, a German soldier and commander of the Royalist cavalry, had made his way to Maidenhead while the king with his army had reached Reading. Farnham was under threat. Wither made several requests for additional men and resources and finally he left the castle heading for London. He claimed to have received orders to do so, but some were to accuse him later of running away from the town.

The following day there were reports that Prince Rupert was in north Surrey. At this point an order was issued by the Parliamentarians for Farnham Castle to be evacuated. Soon after, the Royalists took over the castle, commanded by Sir John Denham, an Anglo-Irish poet who had been appointed High Sheriff of Surrey.

The county was now embroiled in war. The king's army was north of the Thames while Rupert's Royalist cavalry had made its headquarters at Oatlands, and soon after in Egham. After several excursions into and around Surrey, the entire king's army returned to Oxford in November 1642.

Remains of the Chilworth Gunpowder Mills, now a woodland walk.

Meanwhile, back in Farnham, Sir John Denham, lacking resources and arms, was equally unsuccessful in defending the castle for the Royalists as George Wither had been for the Parliamentarians. Sir William Waller, an experienced Parliamentarian soldier, approached the castle and blew up the gates, at which Denham surrendered. Waller went on to clear Surrey of Royalist posts and ordered the shell keep to be blown up to prevent Farnham Castle from being used again as a fortress.

The castle itself was retained by the Parliamentarians as a post for two years and on occasions Waller used it as his headquarters. It was only threatened late in 1643 when Royalist troops approached Farnham Park but then retreated without a fight. It was from the town that Waller launched an attack on the Royalist stronghold at Basing House in Hampshire in late 1643. However, his troops, defiant and disorderly, refused to attack and Waller withdrew back.

There was to be one more, albeit short-lived, Royalist incursion into Surrey. Lord Goring, a Royalist cavalry commander, approached Farnham, which by this time had been left with very little defence. Since he was far from any Royalist support and with little money, he soon left the county. By the end of 1645, the Parliamentarians had gained the

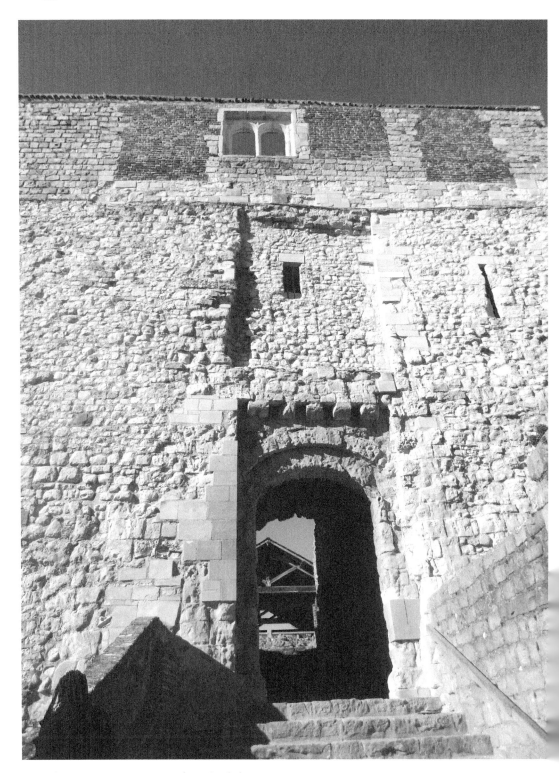

The main entrance into Farnham Castle keep.

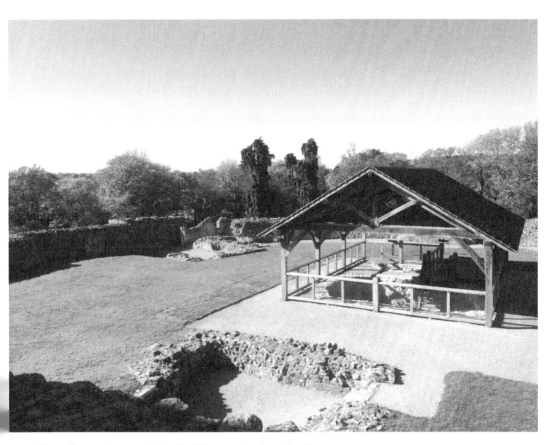

The walls remain around the shell keep at Farnham Castle.

upper hand and Charles I eventually surrendered in May 1646. He was briefly held at Oatlands Palace, near Weybridge, before being transferred to the Isle of Wight.

The country fell into disarray. Those who had opposed the king began arguing and Surrey, like other Parliamentarian counties, was subject to disturbances. The Royalists had been defeated but were still looking for every opportunity to exploit the disagreements between Parliamentarians. Most people still thought of the king as indispensable. To make matters worse, the Parliamentary army had been camped in Surrey at the expense of the county. In December 1647, Surrey farmers presented a petition to Parliament complaining about the freeloading of troops.

In May 1648, there were reports of uprisings and riots throughout the land. In the same month, a meeting was held in Dorking where the residents of Surrey drew up a petition to Parliament calling for the restoration of the king. The petition also demanded an end to free lodging for soldiers and the disbanding of all armies.

Several hundred Surrey men then marched towards Westminster to present the petition to the House of Commons and Lords. Having reached London, the unpredictable spring weather led the petitioners to take refuge in pubs and alehouses. Once the rain had subsided, they presented the petition to the Houses. Growing impatient while waiting

for a response, the petitioners became ever more boisterous, shouting their support for the king. From the Houses, they marched down the Strand towards Charing Cross. It was in Westminster Hall that trouble broke out between the Surrey men and the soldiers on guard. Eventually more troops were brought in and during the confrontation that ensued reports claimed that around ten of the petitioners were killed and a hundred wounded.

Events began to move quickly. The Kent coast was still under control of the Royalists, who rose against the Parliamentarian army and marched into Essex. Since the remainder of the Parliamentarian forces were occupied in Wales and the north of England, the Royalists saw an opportunity to advance into Surrey and Sussex.

The Earl of Holland had been appointed as commander of the Royalist troops in England. Originally a Parliamentarian, he had changed sides on more than one occasion. He bought horses and enlisted men, with Surrey the intended target. Holland raised his standard at Kingston on 4 July 1648 and set out with 600 men towards Dorking, then on to Reigate. It was there that Holland took over the partially ruined castle and managed to resist the Parliamentarian army who were stationed at Redhill.

Racked by indecision, Holland left Reigate for Dorking, tried to return to Reigate and then set off back to Kingston. The Parliamentary army caught up with the Royalists near to Ewell, resulting in an altercation at Nonsuch. The two warring parties clashed again south of Kingston, where the Parliamentary cavalry decided to hold off until their infantry arrived the next day. That night, the Royalist soldiers dispersed no doubt aware of the fate that lay ahead. Holland was captured at St Neots in Cambridge and beheaded in March 1649, three months after the execution of Charles I.

# 4. The Nineteenth Century

The Industrial Revolution and the expansion of the Empire resulted in Britain becoming a prosperous and powerful nation during the nineteenth century. Yet the threat from across the English Channel was never far away. The French Revolution, which began with the storming of the Bastille in 1789, was to sound alarm bells throughout Europe. In 1792, France declared war on Austria and Prussia as well as offering military support to any country wishing to overthrow its monarchy.

In the same year Britain started preparations to counter the menace from France. A military camp was established covering 3 square miles on Bagshot Heath. Cavalry, infantry and artillery amassed from several locations throughout the south-east. The 2nd Queen's Regiment of Foot marched from Portsmouth, the Royal Artillery arrived from Woolwich and the 10th Regiment of Light Dragoons rode from their quarters in Lewes and Brighton.

The purpose of this significant gathering was to try out new military tactics. The camp culminated in a review by George III as cavalry and infantry lined up in front of their canvas tents. The *London Chronicle* reported: 'An elegant marquee is ordered to be pitched at Bagshot-heath when the intended review takes place, for the convenience of the King and Royal Family.' The camp was closed down shortly after George's visit.

In 1799, Napoleon Bonaparte seized power in France. Attempts at peace between the two countries through the Treaty of Amiens in 1802 were short-lived and war resumed in May the following year. Napoleon had been intent on invading Britain for some time and his Grande Armée of 100,000 men gathered at Boulogne while boats were prepared to cross the Channel.

To counter this threat, several acts were passed by Parliament with each county required to raise additional forces to defend the nation. The Defence of the Realm Act of 1804 specified that Surrey needed to provide an extra 1,800 men. The danger of an invasion subsided with Napoleon's preoccupation with the war against Austria and Russia and his defeat at Trafalgar in October 1805. There have been claims that Lord Nelson stayed at Burford Bridge Hotel near Box Hill, then called the Fox and Hounds, on his way down to Portsmouth to join his ship, HMS *Victory*, prior to the Battle of Trafalgar. Even if this remains a matter of conjecture, Nelson and Lady Hamilton were known to have visited the Fox and Hounds on previous occasions.

Communications between the Admiralty and the naval fleet on the south coast were regarded as critical. In response to the French development of semaphore signalling in the 1790s, the Admiralty decided to construct a line of basic semaphore stations connecting the Admiralty in Whitehall with Portsmouth. Two of these temporary semaphore stations were located in Surrey at Netley Heath near Shere and at Hascombe. The stations were closed in 1816 following the end of the Napoleonic Wars.

Nevertheless, the temporary system was considered to have been a success and approval was given for the Admiralty to design and construct an improved, more permanent

semaphore line consisting of fifteen stations between Whitehall and Portsmouth. The sites selected in Surrey were at Chatley Heath, Pewley Hill, Bannicle Hill, Coopers Hill, Worplesdon Glebe and Haste Hill.

The best preserved of these towers is at Chatley Heath near Cobham, a site purchased at the time for £35. The tower consisted of five floors topped by a mast of 30 feet, which had two signalling arms. The mast and mechanism were all in place by June 1822. The semaphore line remained in use until 1847 when semaphore was replaced by the development of electric telegraph communications. Chatley Heath tower is now scheduled as an Ancient Monument and owned by the county council. It was restored and opened to the public in 1989. The semaphore station at Pewley Hill, near Guildford, is now a private residence.

The Royal Military Academy Sandhurst lies on the border between Surrey and Berkshire. The main, ceremonial entrance is situated on the A30 London Road in Camberley. The academy originally began life as the Royal Military College for cadets, which opened in 1812. The site was expanded in 1862 with the construction of The Staff College for training of commissioned officers. The town of Camberley, originally named Cambridge Town, grew rapidly just south of the college. The Royal Military College was amalgamated with the academy from Woolwich in 1947 to become the Royal Military Academy Sandhurst.

Long-time enemies Britain and France were to join forces against Russia in the Crimean War in a dispute over the Ottoman Empire. In preparation for war, a one-month training camp for British soldiers was held on Chobham Common. As with the Bagshot camp of 1792, troops representing all areas of the army were present, including cavalry, foot guard, infantry, artillery and engineers.

Planning for the Chobham camp began in May of 1853. The amount of work involved was considerable. The *Illustrated London News* reported the preparations in detail. The camp was approximately 7 miles across. Officers had small separate marquees, while there was one tent for every fifteen soldiers. A slaughterhouse and canteen were erected and separate stables were built for the horses of the dragoons, artillery and officers. Two separate buildings were taken over in the locality – one as a tavern, the other a hospital.

June saw the arrival of 10,000 men and 1,500 horses who were soon fully occupied with various manoeuvres, charges and retreats as well as parades and inspections. The sound of bugles and cannon fire filled the air, gun smoke hanging over the common. Engineers practised bridge building across Virginia Water. It proved to be quite a spectacle, with trains bringing thousands of visitors from London to Chertsey and Woking in addition to sightseers from the local area.

The highlight of the camp was a visit by Queen Victoria, Prince Albert and several of their children. The royal entourage travelled by train to Staines, continuing their journey to the camp in a horse-drawn carriage. The event was attended by up to 100,000 spectators. A mock battle took place followed by a review with troops filing past the onlooking royals, after which they retired to a pavilion for lunch. One year later, those same troops who had paraded in front of the royal couple were to enter battle in the Crimean War in conditions far removed from those at the camp. Britain was to lose over 20,000 men during the war, many from disease, before Russia was finally defeated in 1856.

In spite of the collaboration between Britain and France during the Crimean War, there was continued suspicion of the French under Napoleon III. In 1859, a Royal

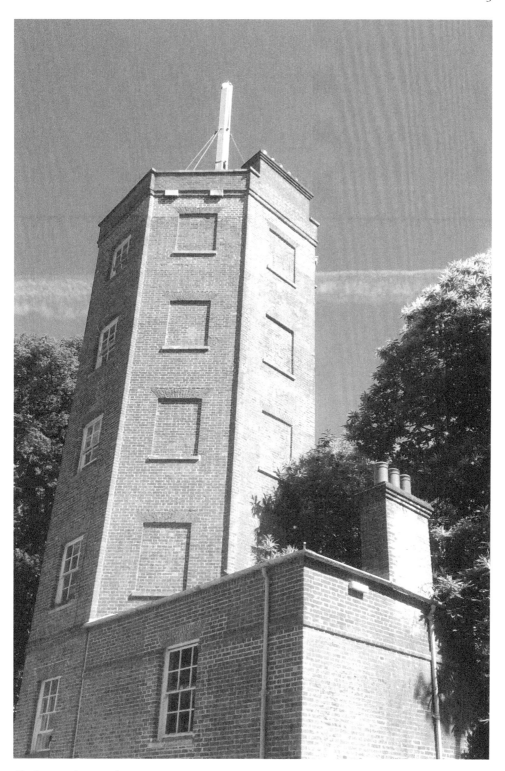

Chatley Heath semaphore tower.

The semaphore station at Pewley Hill in Guildford is now a private residence.

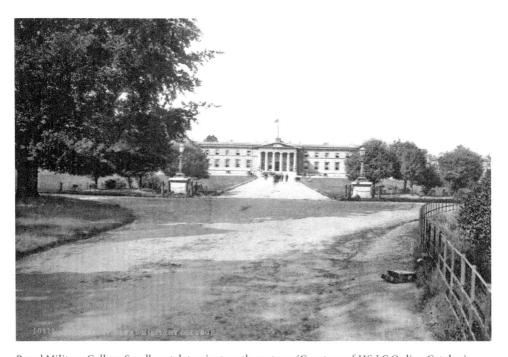

Royal Military College Sandhurst, late nineteenth century. (Courtesy of US LC Online Catalog)

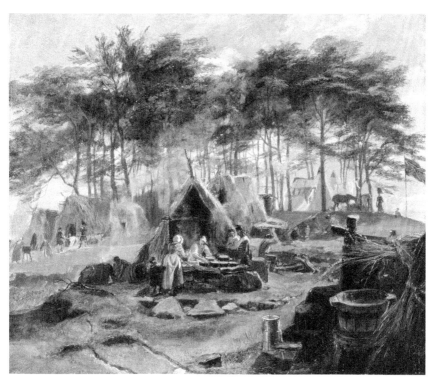

Chobham Camp 1853. (Courtesy of the Council of the National Army Museum, London)

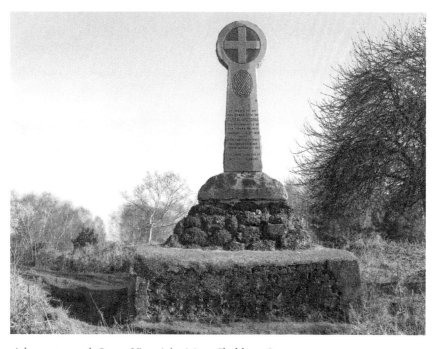

Memorial cross to mark Queen Victoria's visit to Chobham Common camp.

IN MEMORY OF
THE NOBLE LIFE OF
QUEEN VICTORIA
WHO REVIEWED 8.129 OF
HER TROOPS ON THIS
COMMON JUNE 21ST 1853

AFTER A REIGN OF 63 YEARS
SHE RESTED FROM HER
LABOURS JANUARY 22ND 1901

THIS CROSS IS ERECTED BY
400 PARISHIONERS
1901

Inscription on the memorial cross at Chobham Common.

Commission was formed to look into the defences of Britain. The growth and modernisation of the French naval fleet had not gone unnoticed and raised concerns. As a result, forts were commissioned to be built along strategic sections of the south coast.

It was felt among some MPs and military leaders that Britain should not rely solely on its navy to protect the country and that London, without any defences, was at risk. In 1888, the government accepted a plan to build a series of fortified positions, known as mobilisation centres, to the south and east of London, which would be manned by a force of volunteer divisions in the event of an invasion.

The proposed line, the London Defence Scheme, stretched for a total of 70 miles from Guildford through to Godstone and onwards into Kent. Thirteen mobilisation centres were completed by 1903, with nine located in Surrey: Henley Grove and Pewley Hill near Guildford, Denbies, Box Hill, Betchworth, Reigate, East Merstham, Foster Down and Woldingham.

The fortification on Reigate Hill is typical of the larger forts, consisting of a magazine for storing gunpowder and ammunition and a tool store for keeping equipment necessary for the digging of trenches, all surrounded by a large earthen embankment. Two caretaker's cottages were constructed near the fort entrance. The fort was built at a cost of £14,000 for land and works, roughly equivalent to £1.6 million today. Smaller constructions on either side of Reigate at Betchworth and Merstham cost £6,000.

The transformation of the British navy in the early 1900s meant that Britain became the world's leading naval power and invasion was no longer considered a risk. There had been opposition to the cost of the mobilisation centres from the outset and on the 8 March 1906 the Secretary of State for War, Richard Haldane, brought an end to the London Defence Scheme. During a speech in the House of Commons, he said:

> Anyone who knows Surrey, and goes down into the neighbourhood of Dorking, will find there certain curious structures. You will find there large wire fences surrounding seven to nine acres of land, and a large construction that looks more like a water-tank than anything else, containing ammunition of various sorts. These constructions had a definite origin ... when people had not the confidence in the Navy that they have in it today.

Haldane then proceeded to outline that the mobilisation centres would be decommissioned 'as fast as they can be made to disappear' and the decision to sell the sites came in February 1907.

Reigate Fort was sold that same year, but requisitioned during the Second World War. In the 1970s the fort was designated as an Ancient Monument by English Heritage. Having fallen into disrepair, it has since been restored and is open to the public. The caretaker's cottages are now private residences. The Box Hill site was resold to its original owners, Hope Clinton Trustees, in December 1908.

The hardship experienced during the Crimean War led to concern over the condition of the British Army both at home and overseas. A Royal Commission in 1857 had 'examined the barracks and military hospitals of the United Kingdom, and found their sanitary condition as to overcrowding, want of ventilation, want of drainage, imperfect water

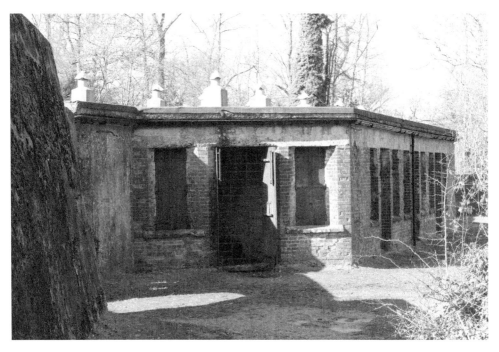

Victorian mobilisation centre at Box Hill.

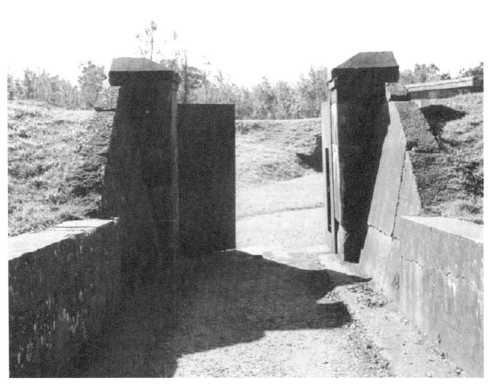

Entrance to Reigate Hill Mobilisation Centre.

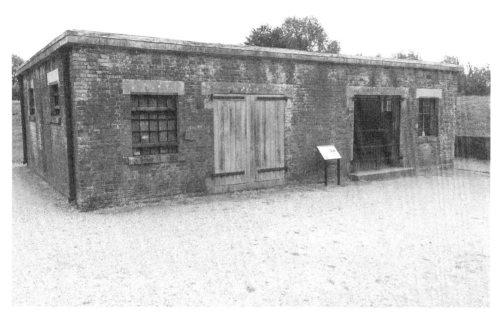

The tool store at the Reigate Hill Mobilisation Centre.

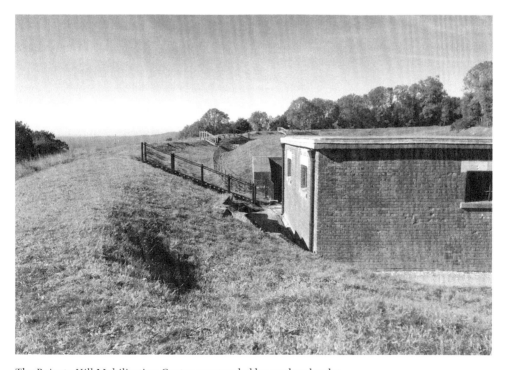

The Reigate Hill Mobilisation Centre surrounded by earthen banks.

supply, sufficient to account for most of the excessive death rate from which the troops occupying them had suffered'. The unsatisfactory treatment of soldiers made it difficult to enlist new recruits.

Edward Cardwell, Secretary of State for War, introduced significant army reforms in the 1870s. Under the Localisation Act of 1872, he reorganised regiments based along county boundaries and commissioned the construction of new barracks, with a design offering much improved conditions. One of the features of the new design was an imposing central 'keep', which served as an armoury.

Stoughton Barracks in Guildford was one of the first of the new barracks to be built in Surrey. It became home to The Queen's Royal Regiment (West Surrey) in 1881, by which time there were 500 servicemen and their families in residence. During the First and Second World Wars it was used as a recruitment and training centre. The barracks closed in 1983 and remained empty until the 1990s when it was redeveloped into housing. The area still retains the name 'Cardwells Keep'.

Stoughton Barracks, Guildford.

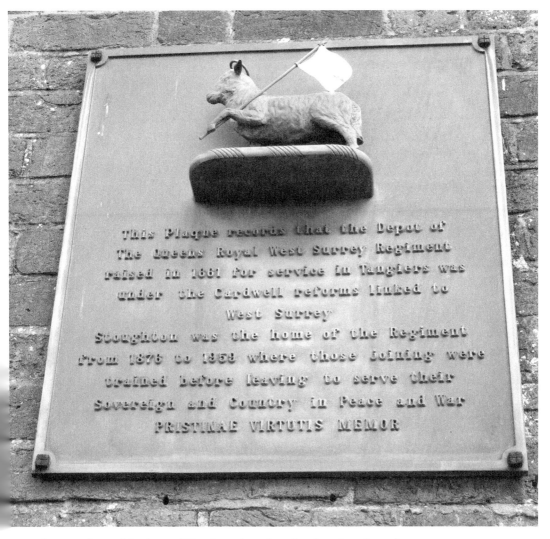

This Plaque records that the Depot of
The Queens Royal West Surrey Regiment
raised in 1661 for service in Tangiers was
under the Cardwell reforms linked to
West Surrey
Stoughton was the home of the Regiment
from 1876 to 1858 where those joining were
trained before leaving to serve their
Sovereign and Country in Peace and War
PRISTINAE VIRTUTIS MEMOR

The Queen's Royal Regiment (West Surrey) was based at Stoughton Barracks.

Kingston Barracks was established at the same time as Stoughton. Built on agricultural land, it became the depot for the East Surrey Regiment for almost eighty years. The site was also converted into private residences.

Caterham Barracks was built in 1877 for the foot guard regiments and included improved sanitation, kitchens, training and recreation facilities. The barracks continued in use until the 1990s when the site was sold for redevelopment. A housing estate, together with community facilities, now occupy the site, although some of the original buildings still exist.

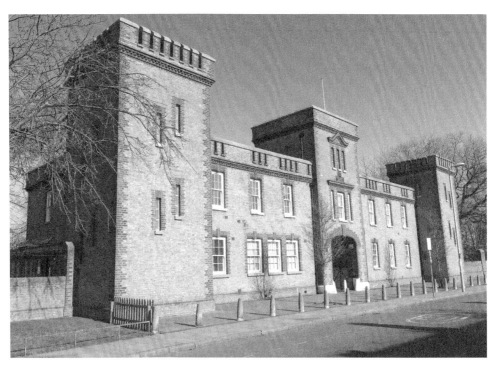

Kingston Barracks, formerly the home of the East Surrey Regiment.

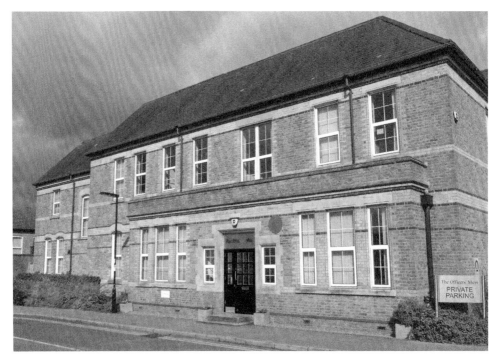

The officers' mess at Caterham Barracks.

Pirbright heath became the site of a camp and training depot for the Brigade of Guards in 1875. It is still used as an army training centre and is home to the Welsh Guards and a Parachute Regiment. The area around Deepcut had been used for military training for some time. Deepcut Barracks, originally called Blackdown, was opened in 1903 near Camberley, built by the Royal Engineers. Now known as the Princess Royal Barracks, home to the Royal Logistics Corp, the site is gradually being decommissioned, transferring to new facilities in Winchester.

# 5. First World War

The First World War (1914–18) was a brutal, drawn-out encounter that would result in over 700,000 British and 230,000 Commonwealth soldiers losing their lives. The conflict was to change the face of Britain forever, affecting people throughout the land, and Surrey was no different.

The abundant heathland in Surrey, together with the proximity to the south coast for ease of transport to the Western Front, meant that several military camps were established in the county for training of British and Canadian soldiers. *The Spectator* commented in 1914 that 'The face of Surrey changes with the war. No other county near London offers the War Office such opportunities for development on military lines. It is a county which, with all its beauty—indeed, because of the very reasons which make it beautiful—is dedicated to soldiers.'

In between Godalming and Hindhead there lies 280 acres of heathland. Three camps were constructed there, Witley South, Witley North and Milford. Milford camp was the first to open and November 1914 saw the arrival of the British Army. The *Surrey Advertiser* reported in August 1915 that, 'The great military camp at Witley is rapidly filling up again. During the last few days some West Surrey villages have witnessed the passing of seemingly endless columns of perspiring but tanned and hardy-looking soldiers bound for the huts which cover the once beautiful common.'

This first Canadian soldiers arrived towards the end of 1915 and numbers increased the following year. Rows of corrugated huts sprang up nearby, manned by local shopkeepers plying their trade to thousands of soldiers. This became known as 'Tin Town'. By 1916, the camps housed 20,000 men. Daily life would consist of training in trench warfare, shooting practice, physical exercise and drills. Wilfred Owen, the wartime poet, was stationed at Milford in the summer of 1916 – his poem 'A New Heaven' was written there. Artefacts from the camps at Witley can be found on display in Godalming Museum.

Another military camp was established near to Epsom. At the time, Woodcote Park estate was owned by the RAC as a country club. The land was commandeered by the War Office and was first used by the Public School Brigade. It then became a convalescent home for Commonwealth soldiers and subsequently was occupied by Canadian forces.

Construction began in November 1914. The scale of the camp was impressive. Each battalion was allocated its own huts, with each hut accommodating fifty men. The officers' quarters contained rooms for servants, a mess, reading room and kitchen. Hot and cold showers were provided, together with drying rooms. A large recreation hall was erected with a stage. There was a post office, barber's and newsagent's stall on site. Soldiers could improve on their shooting technique on one of the five rifle ranges.

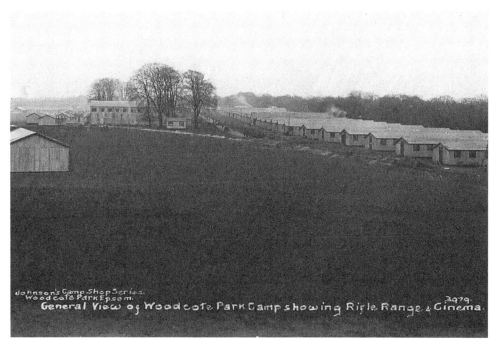

Woodcote Park Camp, near Epsom. (Copyright Bourne Hall Museum)

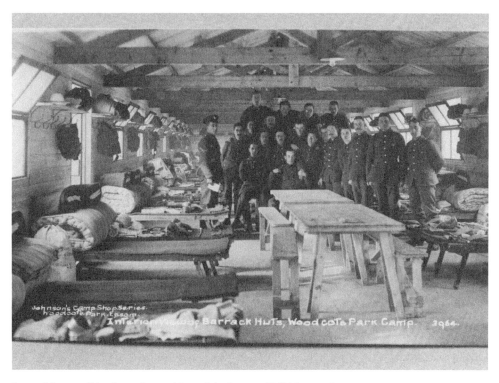

Barrack huts at Woodcote Camp. (Copyright Bourne Hall Museum)

The Public School Brigade, as the name suggests, was a group of men with a public school background aged between thirty and forty-five who had not already been commissioned. The brigade took up residence in February 1915 before moving on to Nottinghamshire for further training. The camp then became the Woodcote Park Convalescent Hospital. The hospital treated troops from Australia and New Zealand who had fought at Gallipoli, followed by troops from the Somme. By September 1915, the number of convalescing soldiers had reached nearly 2,000 comprising of Australians, New Zealanders and Canadians. In July 1916, the camp was occupied mainly by Canadian troops and was taken over by the Canadian Army.

After hostilities had ended, the camp remained with the War Office until it was returned to the RAC in 1923. Parts of the camp were sold off for house building. The Ridge, the site of the main avenue of the camp, is now a private residential road with the same name.

The concentration of troops in the Surrey area resulted in a spectacular scene in 1915. In one of the heaviest snowstorms in many years, 20,000 troops gathered on Epsom Downs on the morning of Friday 22 January. Troops from the surrounding area – including Leatherhead, Dorking and Reigate – had set off from their locations at 4 a.m., marching in the direction of the racecourse. At around 10.45 a.m., Lord Kitchener, Secretary of State for War, arrived together with Alexandre Millerand, the French Minister of War, and the inspection began.

The parade took place close to the grandstand, with troops stretching away towards Tattenham Corner. The snow lay 8 or 9 inches deep, yet, in spite of the weather, a large gathering of civilians came to witness the event. The inspection lasted only a few minutes, the dignitaries passing down two lines of troops before they returned to their car and were driven off.

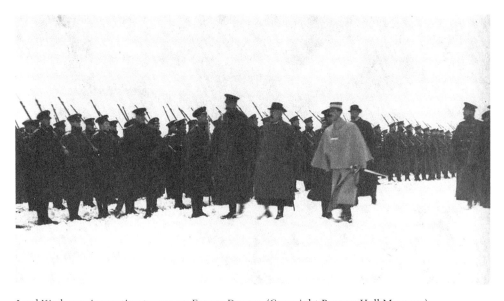

Lord Kitchener inspecting troops on Epsom Downs. (Copyright Bourne Hall Museum)

Soon after Britain entered the war on 4 August 1914, the government passed the Alien Restriction Act. All German nationals living in Britain had to register as illegal aliens and restrictions were placed on their movement. Men of military age who were categorised as enemy aliens were arrested and interned. A German maid was arrested and charged with breaking the 5-mile restriction of movement when her employers brought her down to their country home in Abinger. A shopkeeper from Dorking wrote to the local newspaper to explain that although he had a German name, he was a British national by birth.

In August 1914, a prisoner of war (POW) and civilian internment camp was erected at Frith Hill, Frimley. The camp covered almost 40 acres and was enclosed by a 12-foot-high barbed-wire fence. By the end of September 1914, there were over 2,000 German POWs in the camp, many captured at the First Battle of the Aisne. Special trains brought the prisoners from Southampton to Frimley. With a few exceptions, all were able to march the 2 miles from the station to the detention camp. Large crowds of spectators waited for hours to catch a glimpse of the captives on route.

The sinking of the ocean liner RMS *Lusitania* by a German U-boat on 7 May 1915 led to a significant increase in anti-German sentiment and widespread rioting against residents of German origin living in Britain. An anti-German riot broke out in Bridge Street, Walton-on-Thames during which a watchmaker's shop was attacked. The shop owner, German by birth, had carried out his business in the town for twenty-five years. Stones and other missiles were thrown, smashing windows, and local police were injured while trying to quell the disturbance.

The riots that ensued in towns around the country led the British government to introduce tougher internment criteria. The rounding-up of German residents resulted in 500 German civilians being brought to the compounds at Frith Hill by special train where they were interned alongside German POWs, with more arriving in the following weeks.

The camp became a popular destination for sightseers, with a continuous stream of traffic heading in that direction. The *Surrey Advertiser* reported: 'Vehicles of all descriptions, motor cars, motor charabancs, waggonettes, cycles, and hundreds of pedestrians, were seen along the various roads ... the amount of traffic far eclipsing anything seen during Ascot race week.' The camp was closed during the winter months. Prisoners who had previously been at Frith Hill were brought back from Southend and other locations during spring.

The county also played host to refugees from the Continent. It is estimated that around 110,000 Belgian refugees arrived in England. September 1914 saw the first refugees reach Surrey, with several groups in Farnham, Guildford and Bagshot. Most had fled with only the clothes they were wearing. By the end of October, there were several hundred refugees in the county with more arriving by the day. Local committees were formed in all the main towns to find accommodation with appeals made for funds to accommodate the visitors. Residents received refugees in their homes and empty houses were made available. The Moat House in Reigate was used for housing refugees, as was Sylva House, a large house situated off Waller Lane in Caterham.

At the end of January 1915, increasing casualties led to an Army Council request for 50,000 additional beds. It was decided to offer at least 15,000 beds under the

Asylum War Hospital Scheme. Selected asylums were to be emptied of patients in order to accommodate wounded soldiers.

The patients from Horton Hospital, near Epsom, were transferred to other asylums in a matter of weeks. By June 1915, Horton had opened with 2,238 beds and was receiving sick and wounded men. September 1915 saw the arrival of a large convoy of over 700 wounded soldiers, mostly Australians and New Zealanders who had fought in the Dardanelles. Two months later the hospital received over 100 survivors from the hospital ship HMS *Anglia*, which had struck a mine off the south coast. George V and Queen Mary visited in July 1916. In 1919, Horton was returned to London County Council, having treated over 40,000 patients.

The Epsom and Ewell War Hospital authorities were granted the use of the racecourse grandstand in February 1915 on the condition that the hospital would be closed in advance of the spring racing season. Eventually a compromise was reached where the hospital would give up some of their accommodation for the spring and summer race meetings.

Many of the larger houses and mansions in Surrey were taken over as temporary war hospitals often donated to the War Office or Red Cross by their owners. Waverley Abbey House, near Farnham, was one of the first to be converted to a hospital with sixty beds.

Clandon Park Military Hospital, east of Guildford, opened on 14 October 1914, offered by Lord and Lady Onslow, and equipped using a donation by the couple of £6,000. It was used as a first-line hospital for casualties from the front. The hospital closed on 1 April 1919 having treated over 5,000 patients.

Anstie Grange, on the southern slopes of Leith Hill, was given to the War Office by Mr Cuthbert Heath in August 1916 and equipped as a war hospital at his own expense. A twenty-six-bedroom mansion, it received its first patients within a month. Convoys of wounded soldiers came straight from the front and were de-trained at Holmwood station. Ambulances and lorries transferred patients to the hospital, with the Surrey Volunteer Regiment providing stretcher bearers. By the end of September, over 100 patients had been received.

Polesden Lacey, near Dorking, was used as a convalescent home for recovering officers who no longer needed hospital treatment but required rehabilitation. Officers were treated remarkably well while at Polesden, often with their own bedrooms and bathrooms. The owner, Lady Greville, continued her hectic social life while it was still a hospital, inviting various guests such as Winston Churchill, Rudyard Kipling, George V and Queen Mary.

Heavy casualties on the Western Front meant that more hospital accommodation was needed. The Red Cross set about establishing hospitals at Camberley, Weybridge, Waverley Abbey, Frensham and Bramley. Other hospitals followed at Guildford, Dorking, Reigate and Leatherhead.

When war broke out, Britain had a relatively small army compared to the other leading protagonists but was able to call on support from the British Empire. In addition to troops from Australia, Canada and New Zealand, over a million Indian soldiers fought on various fronts, including France, Belgium, Iraq, Egypt, East Africa, Greece and Gallipoli. By the end of the war around 77,000 had lost their lives, 16,400 were wounded and twelve Victoria Crosses awarded.

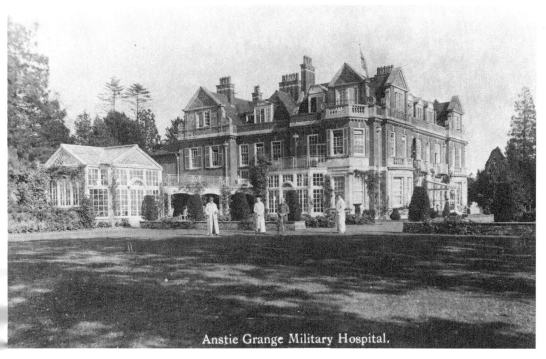

Anstie Grange Military Hospital, near Dorking, *c.* 1916. (Copyright Dorking Museum)

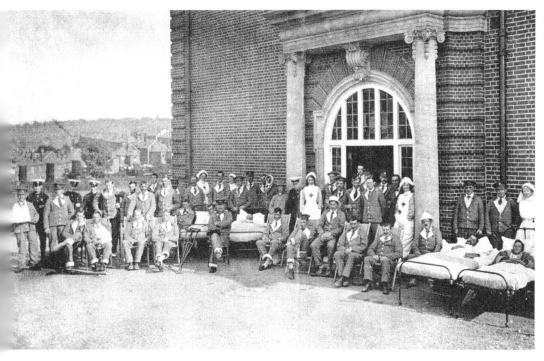

The War Hospital at Guildford County School for Girls. (Copyright Surrey History Centre)

Indian troops were involved on the Western Front from the outset. Hospital ships brought injured soldiers across the Channel to be treated at infirmaries along the south coast. Indian troops who died from their injuries were buried according to religious customs, yet this did not prevent rumours spreading to the contrary. As a result, the War Office decided to establish a dedicated military cemetery for Muslim soldiers and purchased a site near Woking, the location of the Shah Jahan Mosque.

Standing among the silver beech trees on Horsell Common, the Muslim War Cemetery was opened in 1917. Nineteen Muslim soldiers were buried there during the First World War, and eight from the Second. Due to vandalism, the bodies were removed to nearby Brookwood Military Cemetery in 1969. Restoration of the Muslim War Cemetery began in 2013, the walls renovated and a memorial garden built. The 'Peace Garden' was opened by Prince Edward, Earl of Wessex.

The United States entered the war in April 2017. More than 2 million Americans served on the Western Front. A total of 468 American troops that died in Britain from injuries, illness or in surrounding waters are buried in the American Military Cemetery at Brookwood. This includes troops who lost their lives when the SS *Tuscania*, sailing from New Jersey to Liverpool, was sunk by a U-boat off Scotland in February 1918. The ship was

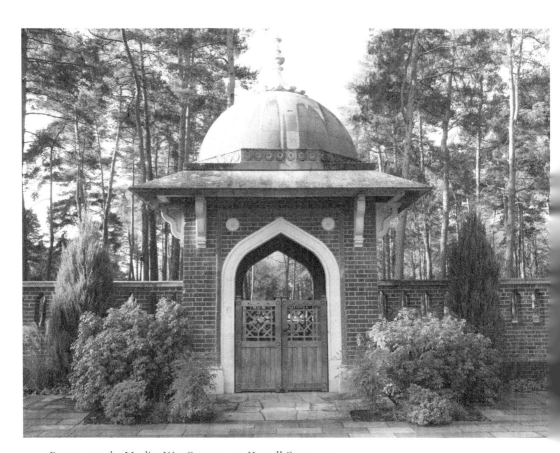

Entrance to the Muslim War Cemetery at Horsell Common.

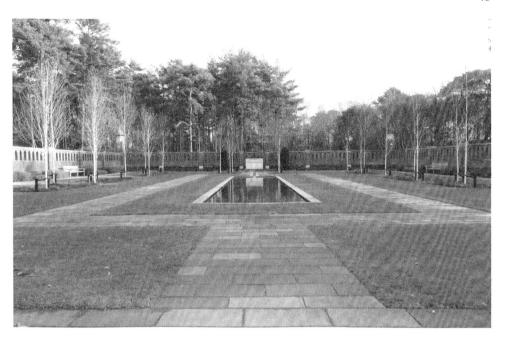

The Muslim War Cemetery is now a 'Peace Garden'.

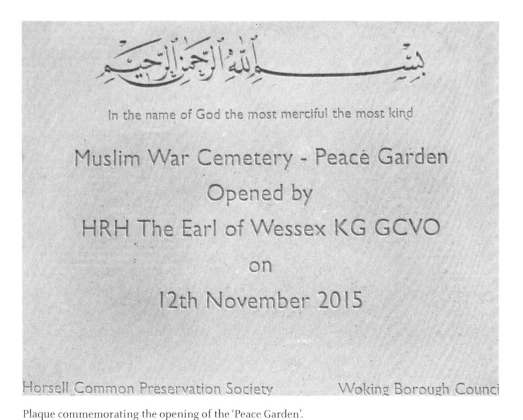

بِسْمِ اللهِ الرَّحْمٰنِ الرَّحِيمِ

In the name of God the most merciful the most kind

Muslim War Cemetery - Peace Garden

Opened by

HRH The Earl of Wessex KG GCVO

on

12th November 2015

Horsell Common Preservation Society          Woking Borough Council

Plaque commemorating the opening of the 'Peace Garden'.

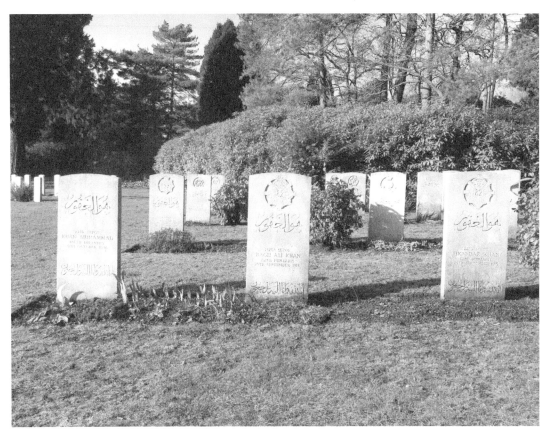

Muslim war graves at Brookwood Military Cemetery.

carrying over 2,000 troops, and 210 of those died. Other troops who perished at sea are remembered in the chapel at the cemetery.

The First World War, infamous for the horrendous stalemate of trench warfare, was at the same time a period of great technological change, including significant advances in aviation. At Brooklands, near Weybridge, you can still find remnants of the steep-banked motor racing track, which opened in 1907 as the first purpose-built racing circuit. Brooklands was soon to become the home of British aviation – both civil and military.

A. V. Roe, the aviation pioneer, tested his first aircraft at Brooklands before founding Avro in 1910, which would go on to manufacture the Lancaster bomber. When Thomas Sopwith set up his aviation company, his aircraft were manufactured in Kingston and brought over to Brooklands for assembly and fitting. Vickers bought a motor works at Brooklands and began the construction of aircraft, building a large estate off Chertsey Road to house factory employees. Martinsyde built a factory in Maybury near Woking, manufacturing several designs of aircraft. The proliferation of aviation companies meant that the airfield also hosted a number of flying schools.

Several companies supplying aircraft parts also came into the area in support of the aircraft manufacturers at Brooklands. Alexander Lang founded the Lang Propeller

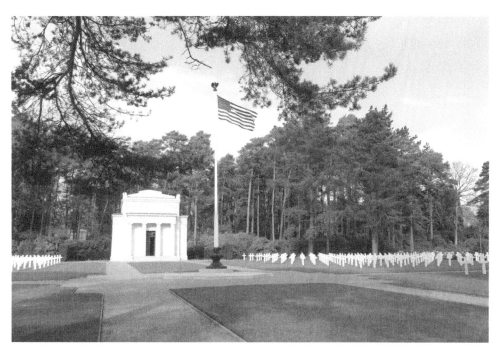

The American Military Cemetery, Brookwood.

The Memorial Chapel commemorates American servicemen with no known grave.

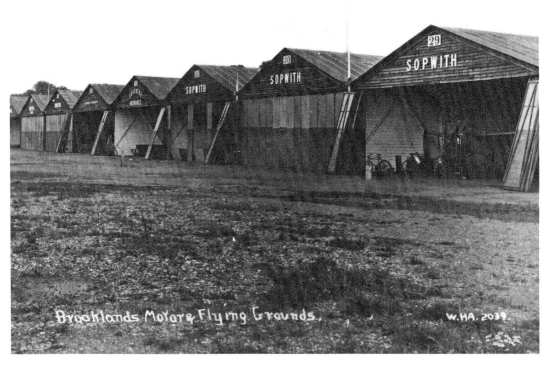

Aviation sheds at Brooklands. (Copyright Brooklands Museum)

Company in 1913 based at Riverside Works, Weybridge, providing propellers made of laminated walnut. The company was eventually taken over by Sopwith in 1917.

Brooklands was requisitioned by the War Department in August 1914 and the racetrack was closed to the public. Several squadrons from the Royal Flying Corps were temporarily stationed at Brooklands in the early part of the war. No. 8 Squadron was formed in January 1915 before transferring to France a few months later. No. 9 Squadron also had a brief stay under the command of Flight Commander Hugh Dowding, later to become commanding officer of RAF Fighter Command during the Second World War.

The number of aircraft at Brooklands increased significantly when in October 1917 it became an Air Acceptance Park for testing of new aircraft, including those from Vickers, Sopwith and Martinsyde. During the First World War, over 4,500 military aircraft were manufactured at Brooklands – more than at any other site in the country. Civil flying resumed in June 1918, and in April 1920 the roar of motor cars could once more be heard as the racetrack reopened.

Brooklands was also instrumental in developing wireless ground-to-air communications. Marconi had set up an experimental establishment there in 1911, which was taken over by the Royal Flying Corps in 1915 for wireless development, testing and training. The first voice transmission to and from an aeroplane took place at Brooklands and was used by aircraft for directing artillery fire on the front line.

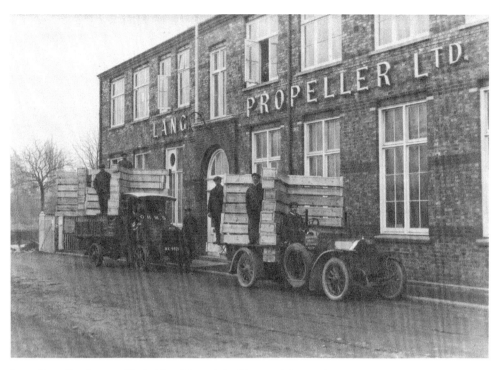

Lang Propeller factory, Weybridge. (Copyright Chertsey Museum)

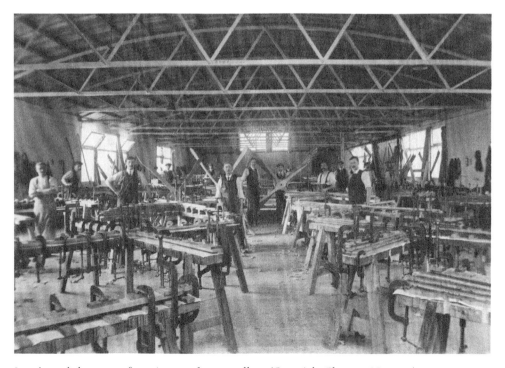

Lang's workshop manufacturing wooden propellers. (Copyright Chertsey Museum)

It was the first time that Britain had come under air attack. The first assault by a Zeppelin was on Great Yarmouth and Kings Lynn in January 1915. The Germans targeted coastal towns and London, yet weather conditions meant that raids were unpredictable and Surrey was not to escape. Captain Heinrich Mathy, one of the most experienced Zeppelin commanders, found himself in Zeppelin L13 over Essex on the night of 13 October 1915. His target was most probably the waterworks at Hampton, yet he ended up over Guildford and dropped twelve bombs on the main railway line just south of the station. There were no casualties.

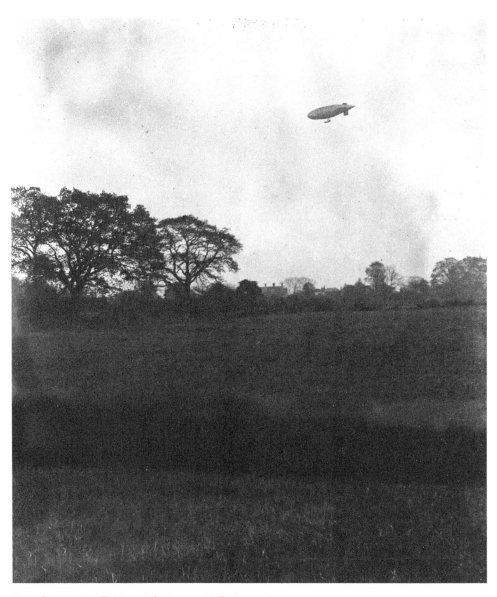

Zeppelin over Ewell. (Copyright Bourne Hall Museum)

The Armistice between the Allies and Germany was signed at 5 a.m. on 11 November 1918, with a ceasefire coming into operation six hours later. Yet, following the end of hostilities, repatriation of Commonwealth troops proceeded at a very slow pace leading to frustration, boredom and confusion. By the summer of 1919 there were still over 2,000 Canadian soldiers in Woodcote Park Camp near Epsom.

Trouble had been brewing over a period of time between local men, who were mostly ex-soldiers, and Canadians in Epsom town centre. One such occurrence took place on the evening of Tuesday 17 June 1919, during which a Canadian soldier was arrested. A group of soldiers attempted to free their colleague but were seen off by the local police who arrested a further soldier for obstruction. The group returned to their camp and word spread about the arrests. Shortly before eleven o'clock, an estimated 400–500 Canadians left the camp, heading for Epsom police station. Armed with iron railings and wooden stakes, they stormed the station.

The police were eventually overwhelmed. The Canadians managed to free their two colleagues and returned to their camp. Practically every policeman had been injured during the battle – some worse than others. Station Sergeant Thomas Green, aged fifty-one and close to retirement, was taken unconscious to the local hospital and died the following morning having suffered a fractured skull. Seven Canadian soldiers appeared in court charged with manslaughter and riot. Five were found guilty of rioting and sentenced to one year in prison. The men were released early, handed over to the Canadian authorities and returned home.

In August 1929, New Scotland Yard received a telegram from the chief of police in Winnipeg. One of the soldiers, having been arrested on a minor offence, had decided to clear his conscience. He admitted killing Station Sergeant Green by striking him on the head with an iron bar. New Scotland Yard replied that since the case was closed, no further action would be taken.

Witley Camp near Godalming was also to experience trouble on more than one occasion. On 11 November 1918, the night of the Armistice, Canadian troops looted shops in 'Tin Town'. Further disturbances took place in February 1919. The most serious rioting came on 14 and 15 June 1919 when several hundred troops looted and burnt shops, fortunately without fatalities. The soldiers defended their actions blaming the delays in demobilisation and profiteering by shopkeepers.

These incidents and others in demobilisation camps throughout the country led to the British government speeding up the repatriation of Canadian soldiers. Almost all had left these shores by the end of the summer of 1919.

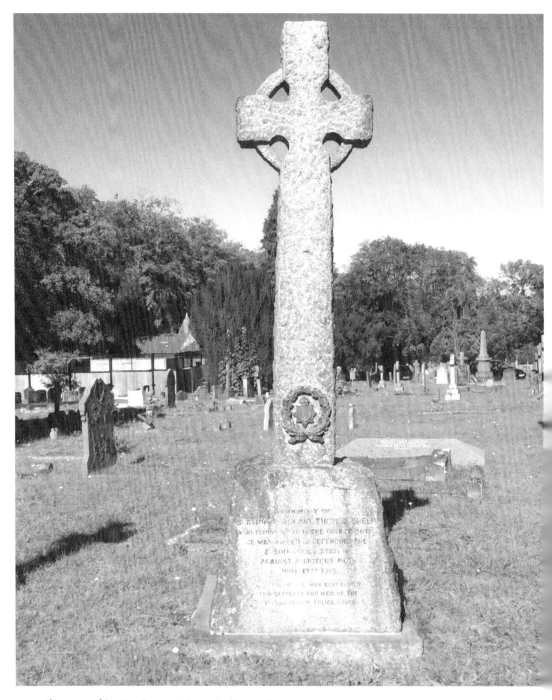

The grave of Station Sergeant Green in Epsom Cemetery.

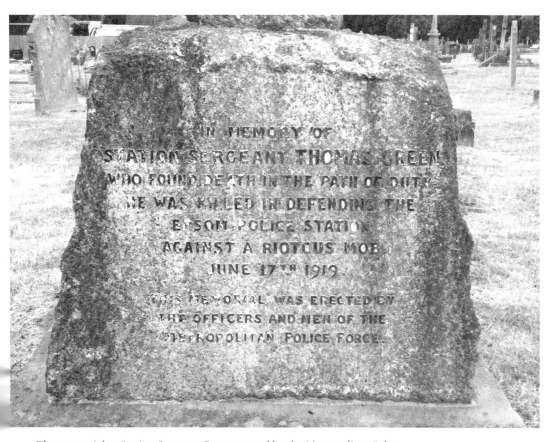

The memorial to Station Sergeant Green erected by the Metropolitan Police.

# 6. Second World War

It was at 11.15 a.m. on a warm Sunday morning on 3 September 1939 that Prime Minister Neville Chamberlain made a broadcast to the nation. The British government had given Germany an ultimatum to withdraw their troops from Poland. Chamberlain continued, 'I have to tell you now that no such undertaking has been received, and that consequently this country is at war with Germany.' The government had already introduced a number of regulations and directives, resulting in wide-ranging measures being swiftly initiated on declaration of war.

The fear of bombing raids by the German Luftwaffe led to a mass evacuation, codenamed Operation Pied Piper, during the first weekend that September. Regions were designated as either 'Evacuation', 'Reception' or 'Neutral' areas. Most of Surrey was considered to be a reception area. Neutral areas, that would not send or receive evacuees, included Epsom and Ewell, Banstead, Caterham, Esher, Farnham, Frimley and Camberley.

The first three days of September saw 8,000 London schoolchildren arrive at Woking station. They were taken to various schools and allocated to billets in private houses throughout the area. Around 6,000 were received at Chertsey and 3,000 at Dorking. The *Surrey Advertiser* edition of 6 September 1939 commented:

> Few watchers could have remained unmoved by the scenes in and around Guildford Station during the week-end. The thousands of children with their quota luggage were bright and chattering as children will be, but it was impossible to forget that they had all been separated from their homes for a period that no one can measure.

The Redhill and Reigate areas received 5,000 evacuees, although some considered that these districts were too close to London to be safe.

In addition to the government priority class of evacuees, many private evacuees descended on the county. Firms that had relocated from London brought their employees. By the end of September, the population of Woking was estimated to have risen from 40,000 to 50,000 while the number of residents in Leatherhead had also increased by 25 per cent. The influx led to a shortage of billets in some areas. Councils were given powers to prosecute, if necessary, persons who refused to take in evacuees.

Further evacuations from large cities occurred when the Blitz commenced in September 1940. The last wave of evacuations took place during the V-1 flying bomb campaign that started in June 1944. The areas of Surrey that had been designated as reception areas were now subject to evacuation due to the risk posed by flying bombs falling short of London. Around 1,400 children were evacuated from Redhill and Reigate bound for Wales and Somerset, including some brought down from London during the Blitz. Children from Cobham and Epsom left for Devon.

It would be a matter of months before they would return. Over a thousand evacuees returned in December, arriving at Redhill and Reigate stations in special trains to joyous homecoming scenes. Houses that had been left empty were readied by the Women's Voluntary Service and Billeting staff, delivering coal and food to returning families.

In 1945, the British government agreed to accept 1,000 children with no surviving family who had been liberated from concentration camps. In the end 700 children entered the country. After arriving in Cumbria, some of the children were moved to a large country house, Weir Courtney, in Lingfield where they attended local schools. In 1948, the children were relocated to Isleworth, Middlesex.

Secretly, Germany had been rearming since 1933. Two years later, Hitler openly announced the formation of the German air force and army conscription, contrary to the terms of the Treaty of Versailles. As a result, a major RAF expansion scheme was approved by the government in February 1936 proposing an increase in aircraft over the next three years. Brooklands, near Weybridge, would be at the forefront of that expansion. Two of the main beneficiaries of the scheme were Hawker Aircraft, formed from Sopwith Aviation, and Vickers. Both companies would go on to produce aircraft that would play a critical role during the war.

The Hawker Hurricane had first flown at Brooklands in November 1935 and became a mainstay of RAF Fighter Command. During the war over 3,000 Hurricanes came out of Brooklands until production was relocated to Langley, near Slough, at the end of 1942. The site then became purely a Vickers manufacturing facility. Around 2,500 Wellington bombers were built there during the war.

Vickers took over Wisley Airfield, around 4 miles south of Brooklands, in 1943. Part-assembled aircraft were taken by road to Wisley for final assembly before delivery to the RAF. The airfield was also used for testing of prototype aircraft.

One of the chief designers from Vickers would become a household name. Barnes Wallis joined the company in 1913, initially as an airship designer. He transferred to Brooklands in the 1930s to focus on aircraft design. His designs formed the basis of the Wellington bomber, manufactured using a lattice structure, which made the aircraft light and durable. But perhaps he is best known for the 'bouncing bomb' used during the Dambusters raid in May 1943. Initial tests at the conceptual stage took place at nearby Silvermere Lake using a catapult system. He went on to develop the 'Tall Boy' bomb, used against V-1 flying bomb launch sites and the Battleship Tirpitz, and the larger 'Grand Slam'. After the war, Barnes Wallis continued his employment at Vickers until he retired in 1971. He lived in Effingham for many years and is buried at St Lawrence's Church in the village.

The significant contribution of Brooklands to the war effort was clearly not to go unnoticed. On 4 September 1940, up to fourteen Messerschmitt Bf110 aircraft, protected by escort fighters, crossed the Channel. Their target: the Vickers factory. The attack caught Brooklands completely by surprise. Air-raid sirens remained silent, anti-aircraft guns returning fire only after the raiders had dispatched their payload. Eighty-three workers died and over 400 were left wounded. The death toll would have been even higher had the raid not taken place at lunchtime.

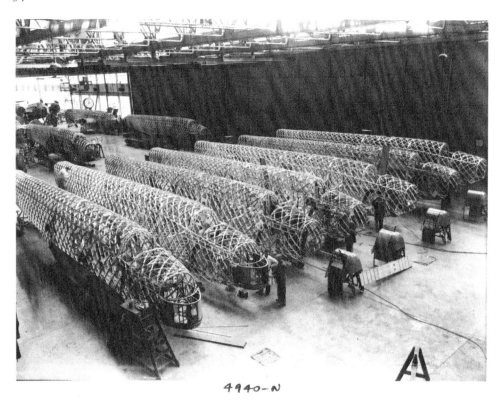

4940-N

Wellington bombers at Vickers factory, Brooklands. (Copyright Brooklands Museum)

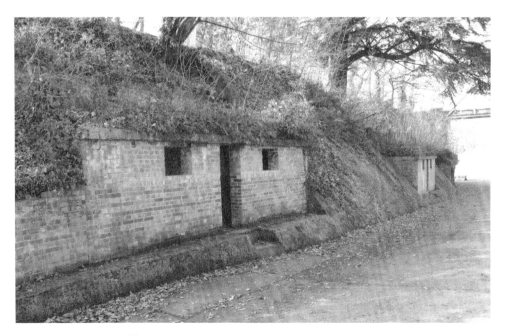

Air-raid shelters at Brooklands.

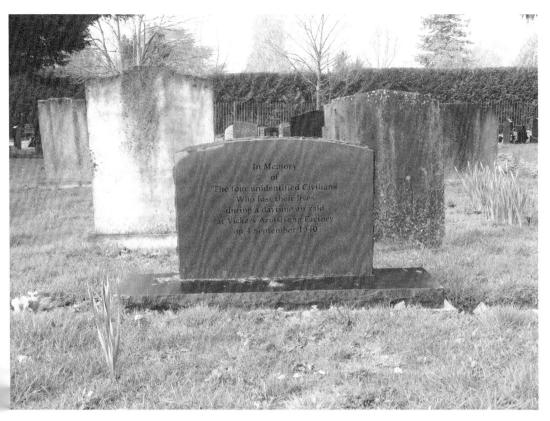

Unidentified victims from the Brooklands air raid are remembered in Burvale Cemetery.

In spite of the extensive damage, production of Wellingtons resumed within twenty-four hours, albeit at a reduced rate. Following the air raid, several of the manufacturing operations at Brooklands were dispersed to smaller workshops in the locality. Barnes Wallis and his team relocated to Burhill Golf Club in Hersham. Other design engineers went to Foxwarren near Cobham.

Not only was Surrey the site for manufacturing of military aircraft, airfields throughout the county played a major part in the Battle of Britain. Take a walk around the perimeter of Kenley airfield, near Caterham, today. Enjoy the peace and quiet as gliders soar silently above in sharp contrast to the events that were to unfold there in 1940. Kenley was taken over by Fighter Command in 1936 as the main RAF station in the county. In 1939 concrete runways were laid to accommodate Hurricanes and Spitfires. Kenley became the controlling airfield for Sector B of Fighter Command No. 11 Group.

On the afternoon of 18 August 1940, nine German bombers flew over the south coast heading towards Kenley. Flying low, they attacked the airfield causing significant damage. Nine people were killed and ten wounded. Three hangars were destroyed and ten aircraft damaged, yet the airfield was operational the next day. Another attack took place in early September but little damage was caused and soon after the Luftwaffe turned their attention to British cities.

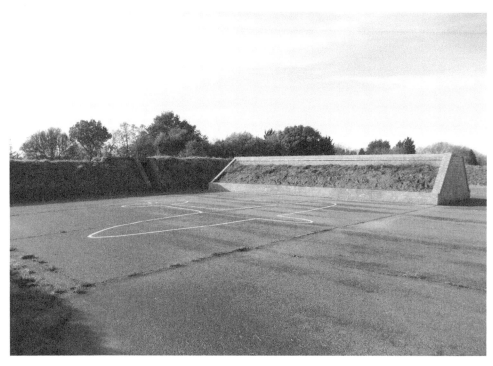

Blast pens designed to protect fighter aircraft at Kenley.

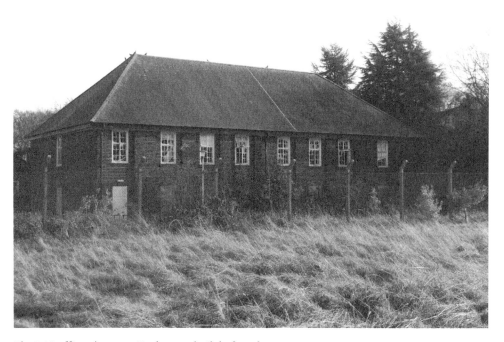

The RAF officers' mess at Kenley was built before the war.

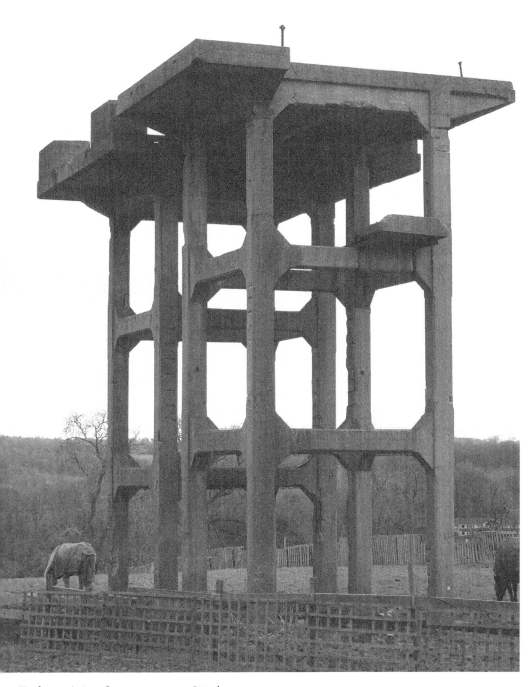

Kenley anti-aircraft gun tower near Caterham.

58

In memory of those who served at RAF Kenley.

The graves of RAF Kenley air crew in 'Airmen's Corner' at St Luke's Church, Whyteleafe.

Redhill airfield was used for RAF pilot training from 1937, later becoming a centre for testing and grading Polish pilots. In January 1941, work begun on laying a runway and in February the airfield became host to Hurricanes, as part of the Kenley wing. In the lead up to D-Day, the airfield was subject to a build-up of supplies and equipment with over 200 aircraft in residence. In was subsequently used by the Canadian Casualty Evacuation Unit where aircraft would bring in the wounded, day and night, to nearby Smallfield Hospital.

In 1941 the Canadian Armed Forces requested permission to build a new airfield, and a site was chosen on agricultural land and woods just outside the Surrey village of Dunsfold. Construction started in May 1942 with an aggressive target of eighteen weeks. In October the site was officially opened consisting of three hard runways. The airfield was initially used for reconnaissance duties. In 1943, two squadrons of B25 Mitchell bombers arrived. As the war drew to an end, Dunsfold became an arrival centre for liberated Allied POWs. By the end of May 1945, 44,000 repatriated troops had passed through the airfield.

Croydon Airport, in Surrey at the time, was the busiest international airport in Europe before the war. On 30 August 1939 all civilian flights were suspended and the airfield taken over by the RAF as a satellite to Kenley. On 15 August 1939, up to thirty German aircraft attacked the airfield. The control tower, hangars and armoury were all damaged. The factory of British NSF Ltd near the airfield, which produced electrical components for the RAF, was destroyed with the loss of thirty lives.

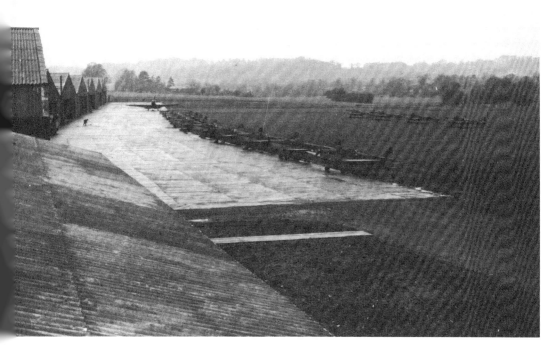

RAF Redhill, 1939. (Copyright Wings Museum)

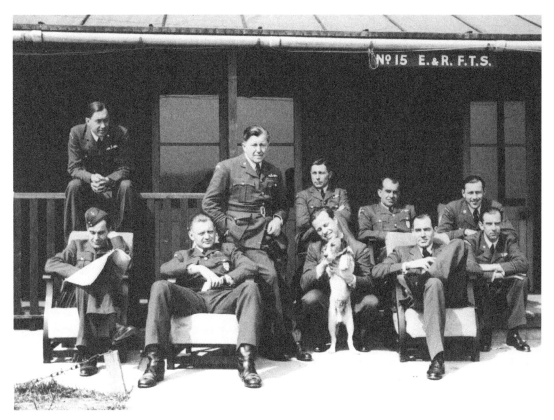

Polish pilot graduates, Redhill, 1940. (Copyright Wings Museum)

In addition to the targeted bombing raids on wartime manufacturing facilities and RAF airfields in the county, Surrey residents were to experience first-hand the danger and destruction from German high-explosive and incendiary bombs. Luftwaffe bombers would release their bombs on route to and from London to enable a swifter return back.

Due to reporting restrictions, local newspapers would only record that bombs had fallen 'on a Surrey town', 'a village in the Home Counties' or 'a town on the outskirts of London'. The specific town or area affected was never disclosed. One particular attack occurred south of Guildford, in December 1942. A single German aircraft dropped three bombs on the village of Bramley and machine-gunned a train. Eight people were killed and thirty-six injured.

A deep air-raid shelter was constructed and opened in January 1942 to the west of Ashley Road in Epsom with a capacity of 1,500 people. The shelter was considered to be impregnable against air attack and consisted of three main corridors of 270 feet and four cross corridors of 200 feet under 40 feet of chalk. Facilities included water sanitation, a ventilation system, a canteen and a medical aide post. The shelter still exists today, the entrance located on private land. A similar deep raid shelter was built at Foxenden Quarry in Guildford.

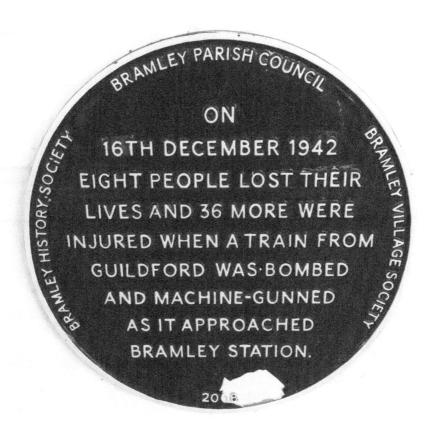

BRAMLEY PARISH COUNCIL

BRAMLEY HISTORY.SOCIETY

BRAMLEY VILLAGE SOCIETY

ON
16TH DECEMBER 1942
EIGHT PEOPLE LOST THEIR
LIVES AND 36 MORE WERE
INJURED WHEN A TRAIN FROM
GUILDFORD WAS·BOMBED
AND MACHINE-GUNNED
AS IT APPROACHED
BRAMLEY STATION.

20 8

Memorial to those killed during an air raid at Bramley.

Although the Luftwaffe bomber offensive against Britain decreased in 1941, the danger did not completely disappear. Residents would still be subject to the menace from V-1 flying bombs, the first landing in June 1944. Parts of Surrey, Kent, and Sussex became known as 'Bomb Alley'. Overall, the total number of casualties from bombing in the county during the Second World War amounted to 2,300 residents killed, 5,216 seriously injured and 8,965 slightly injured.

While playing an important role in the defence of London over the centuries, the picturesque Surrey Hills were on occasions to form an unfortunate obstacle during wartime, claiming the lives of several Allied airmen. In November 1944, three Douglas DC-47 Skytrain military transport aircraft were returning from France to their base in Oxfordshire. In bad weather they flew into the side of Leith Hill, south of Dorking. Thirteen of the crew were killed and two survivors died later of their injuries. The cause of the accident was noted as pilot error in the lead aircraft with weather as a contributing factor. Two further DC-47s were to crash into Leith Hill in November and December of that year.

One Monday in March 1945, in the late afternoon, residents of Reigate heard the roar of engines from an aircraft flying low over town. A Boeing B-17 Flying Fortress from the

US Air Force was returning from a 600-mile round trip after bombing a railway junction in Germany near to the Czech border. Crossing the English coast, the bombers experienced bad weather and the pilots were instructed to return to base in Northamptonshire individually rather than in formation to prevent collisions.

Suddenly there was a deafening explosion. Flying in low cloud and rain, the aircraft had hit the top of Reigate Hill and exploded on impact. Local people, the fire service and police rushed to the scene, but there was little they could do. All of the crew, flying on their thirteenth mission together, were killed. Witnesses reported that they saw thick smoke coming from one of the engines before the crash. Yet an official accident investigation cited that the accident had been caused solely by pilot error. Three of the crew were buried in an American cemetery near Cambridge, the remainder repatriated to their homeland. There is still a clearing among the trees on Reigate Hill where the aircraft came down, together with a memorial to the brave airmen who tragically lost their lives.

The crew of another Boeing B-17 had a luckier escape. The bomber, returning to England, encountered bad weather. In the darkness they got lost. With very little fuel left

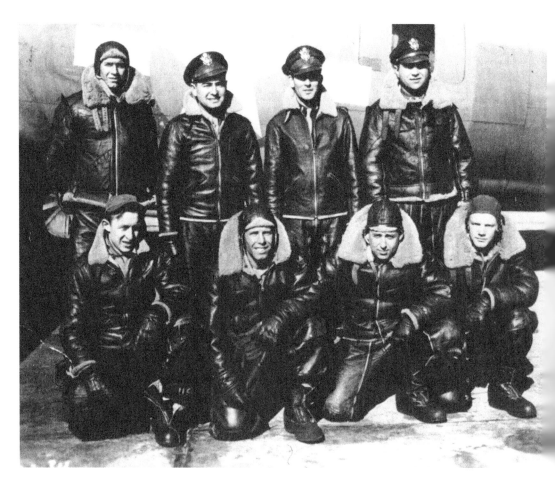

US air crew who lost their lives on Reigate Hill. (Copyright Wings Museum)

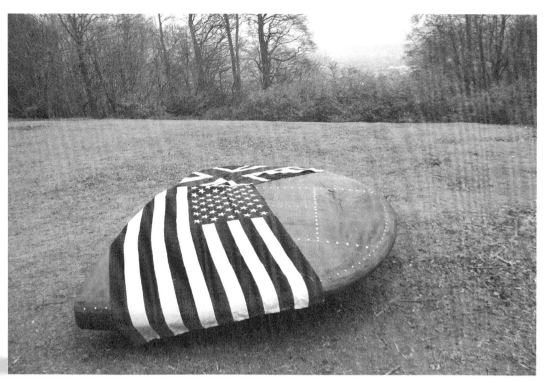

A memorial where the Boeing B-17 crashed on Reigate Hill. (Copyright Mark Richards)

they descended looking for somewhere to land, coming down next to Windsor Road in Egham. The crew escaped unhurt.

In May 1940, the Local Defence Volunteers (LDV) was established when a German invasion seemed imminent. It was open to men between the ages of seventeen and sixty-five who were not involved in active service. In July 1940, at Churchill's insistence, the LDV was renamed to the Home Guard. There were twenty-nine Home Guard battalions covering Surrey in two command areas. The South Eastern Command covered the majority of the county, the London Command included Epsom and Banstead. The first official Home Guard training school in Surrey was established at Denbies, near Dorking, in October 1940.

A weekend training school was set up in the grandstand at Epsom racecourse in the summer of 1941 to train Home Guard from the south-west London area. Around thirty-three battalions attended courses and all told some 130 officers and 3,500 other ranks undertook training at the school practising drills, tactics and grenade throwing. In 1941, 5,000 Home Guard participated in a 'tank battle' on Epsom Downs, with the Royal Tank Corps playing the role of the enemy.

Since London would have been a major objective for any invasion, a system of defence lines was established around the capital. The General Headquarters (GHQ) Stop Line ran through the county using natural obstacles such as rivers, canals and ditches where possible, complemented by pillboxes, tank traps and roadblocks. The intention was to slow down the German invasion forces long enough for British reinforcements to arrive.

There were several designs of pillboxes, typically made of rough concrete or brick, sometimes partially buried into hillsides. The degree of protection could vary, some were shellproof while others only bulletproof. The interior was very basic with little room for home comforts. Narrow unglazed windows, called loopholes, served as lookouts or had mountings for light machine guns. Many were hidden or disguised by camouflage.

The GHQ Stop Line ran from Farnham, through Godalming, Dorking, north of Lingfield on towards Edenbridge and then into Kent. Some of the defences, including pillboxes and anti-tank traps, can still be found along the North Downs Way and in other locations. The defence lines were manned mainly by the Home Guard. Improvisation and scrounging resulted in some interesting approaches to creating roadblocks in the early days. Old cars and barrels filled with stones were sometimes used.

Once again, troops from the British Empire were to make an important contribution during wartime. The first Canadian troops arrived in Britain in 1939, the majority stationed in the south-east. Surrey was to welcome an estimated 10,000 Canadian troops located in camps throughout the county, the Surrey countryside regarded as ideal for training.

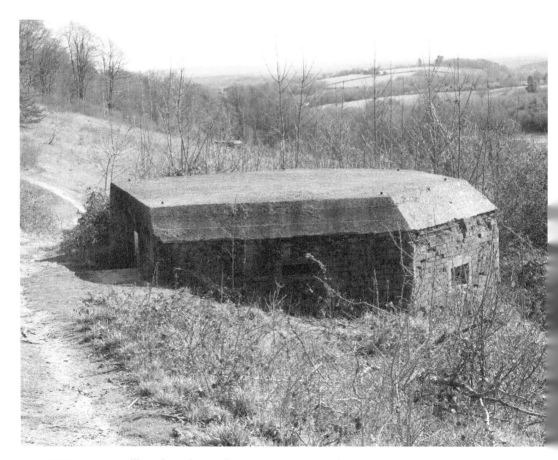

GHQ Stop Line pillbox along the North Downs Way near Dorking.

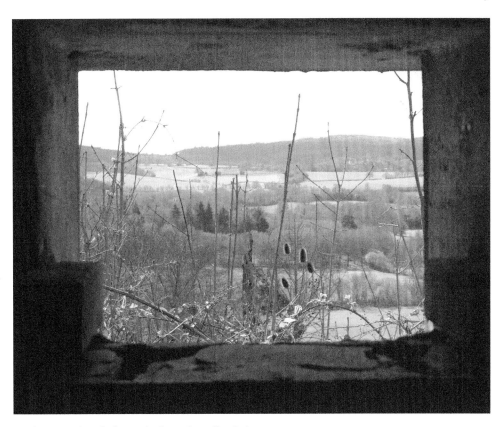

Machine-gun loophole overlooking the valley below.

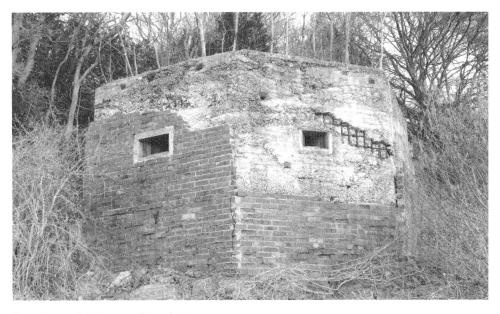

One of several different pillbox designs.

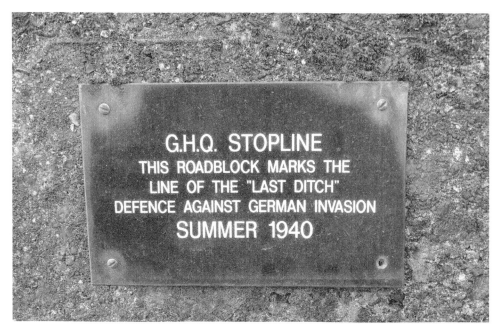

Part of a roadblock still remains on the A281 through Shalford.

Canadian troops left their mark in 1942 on a wall in Chalk Lane, Epsom.

The camps that had existed during the First World Wart at Witley were rebuilt for Canadian troops arriving in May 1941 and used as training camps for reserve infantry and artillery. George VI inspected and honoured the Canadian regiments who had been involved in the unsuccessful raid on Dieppe in August 1942 during which the Canadian forces suffered heavy losses.

Shortly before 10.30 p.m. on a Sunday night in June 1945, residents in the area surrounding Witley were shaken by a huge explosion. An ammunition dump containing grenades, mortars, mines and small arms ammunition had exploded at the camp. Fortunately, no one was killed. Towns and villages as far as Godalming and Haslemere experienced broken windows.

An 'Atlantic Wall' can still be found on Hankley Common. Built in 1943 by Canadian troops, the wall was a replica of the German defences on the French coast and used as practice in preparation for the invasion.

Tweedsmuir Camp was located on nearby Thursley Common, a site already in use by the British Army since the 1920s. In 1941, the land was handed over to Canadian forces and the construction of the camp began. It was principally used as a repatriation centre for injured soldiers returning to Canada. After the war it became home to the families of Polish soldiers who had served with the Allied forces. By 1949 there were still around 100 Polish families living in the camp which was eventually closed in 1960.

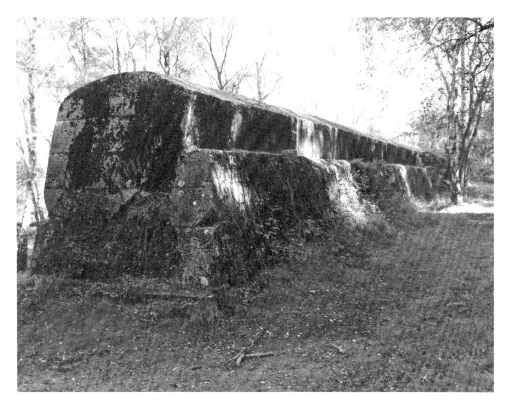

The 'Atlantic Wall' on Hankley Common, used for D-Day training.

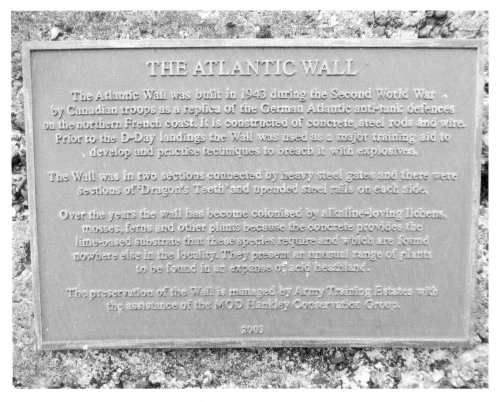

Information plaque on the 'Atlantic Wall'.

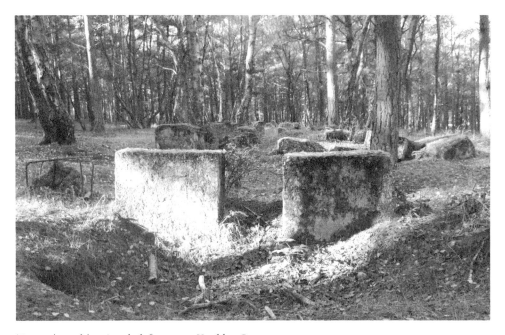

'Dragon's teeth' anti-tank defences on Hankley Common.

Headley Court, a mansion near Leatherhead built in the late nineteenth century, was requisitioned as the headquarters for Canadian forces. After the war, it became a medical rehabilitation centre initially for injured RAF personnel, then expanded to cover all of the armed forces. In 2018, the services provided by the centre were transferred to Nottinghamshire. Nearby Headley Heath was used by the Canadian army as a training ground for engineers in preparation for D-Day.

A thousand Canadian troops gathered on Albury Heath in May 1944 to be inspected by Field-Marshall Montgomery. The assembled troops were told that they would be under Montgomery's command but not their eventual destination. Montgomery's connection with Surrey goes back to December 1941 when he became head of South East Command, based in tunnels under Reigate Hill.

Banstead Woods was requisitioned by the War Department and a camp was built for the Royal Canadian Engineers, Royal Canadian Regiment and Artillery. The majority left the camp in July 1944 in a convoy over 2 miles long. The camp was subsequently used to house Italian POWs, many captured in North Africa. Repatriation of Italian prisoners began in autumn 1945, at which time German POWs began to arrive. They were kept occupied repairing war-damaged houses and preparing building sites, including Fir Tree

The memorial where Montgomery addressed Canadian troops on Albury Heath.

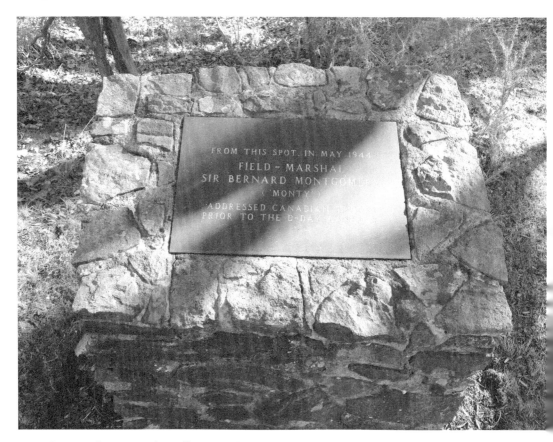

Plaque on the memorial on Albury Heath.

Road, for prefabricated houses. The Germans left in 1947 and Banstead Woods was reopened to the public.

Other locations in the county were to house POWs. Kempton Park racecourse, near Sunbury-on-Thames, was used as a reception camp initially for Italian prisoners. The perimeter of the racecourse was enclosed by a fence including guard towers. Following D-Day, captured German prisoners were brought to Kempton via the south coast ports for registration and interrogation prior to onward transfer to other camps around Britain.

The racecourse in Lingfield was also taken over, initially as an internment camp for those residing in Britain classified as 'enemy aliens'. By 1940 the camp held a thousand internees. The camp was lit by powerful lighting, a local resident commenting that 'at night the camp looks like Brighton front in peace-time.' An attempt to escape was discovered by camp guards, the tunnel originating in the shower block. Eventually the internees were moved on to other camps and the racecourse was used for housing Italian and German POWs. The camp closed in 1945 and reverted to its pre-war owners.

As in the First World War, when some of the stately homes became war hospitals, the larger houses and mansions of the county were to make a contribution to the war effort.

Surrey was to play host to one of the most senior members of the Nazi party. Originally appointed as deputy führer, Rudolf Hess had seen his influence decrease amongst the Nazi hierarchy. On 10 May 1941, he took off from an airfield in Germany heading for Britain, eventually parachuting out of his aircraft over Scotland. His intention: to open peace negotiations with the British.

Initially held in the Tower of London, Hess was transported to Surrey in an ambulance on 20 May 1941. Mychett Place, a mansion 4 miles south of Camberley, was to be his home for the next thirteen months. Several meetings took place there between Hess and government officials after which a report was compiled for Winston Churchill. The conclusion was that Hess was mentally disturbed. During his time at Mychett, Hess suffered from severe depression, writing suicide notes to his wife and Hitler. He feared that his guards were trying to poison him. On one occasion he attempted suicide by jumping over a banister where he fell 25 feet, breaking his leg.

The cost of keeping Hess as the only resident at Mychett was increasing and his mental condition suggested that a mental institution would be more appropriate. On 26 June 1942, Hess was moved to a military hospital near Abergavenny in Wales. After the war he was put on trial at Nuremberg and sentenced to life imprisonment. He committed suicide in Spandau Prison, Berlin, in 1987 aged ninety-three years.

Deepdene House, Dorking, and the surrounding land was in its time one of the grandest estates in the area. It became a hotel in the 1920s until it was taken over by Southern Railway for the duration of the war. Providing a critical service transporting troops and supplies, Southern relocated its headquarters from Waterloo to avoid disruption from air raids.

The headquarters of Southern Railway, Deepdene House, 1940. (Copyright Dorking Museum)

In the hall of the Deepdene 'Hotel,' a large country house, day and night throughout the War, experts planned the special trains for H.M. Forces

Southern Railway planners at work in Deepdene House. (Copyright Dorking Museum)

The caves underneath the house were converted into bunkers where the telephone exchange and railway traffic control centre were located, housing thirty staff. British Rail vacated the premises in the 1960s after which the house was demolished and replaced by an office block.

The Special Operations Executive (SOE), a secret organisation of spies and saboteurs formed in 1940, took over numerous residences throughout Britain for training purposes. Several of those were located in Surrey including Wanborough Manor and Tyting House (both near Guildford), and Gorse Hill, Witley.

One of the SOE centres was at Villa Bellasis in Box Hill Road, Dorking. It was from there that a team of Czech agents left for their homeland on an assassination mission, Operation Anthropoid. Their target was Reinhard Heydrich, who had previously been head of Gestapo and was one of the main instigators of the Holocaust.

After training at various SOE locations throughout the country, the agents, led by Jozef Gabcík and Jan Kubis, arrived at Villa Bellasis in November 1941 for final preparations. They were parachuted into Czechoslovakia at the end of December. A bungalow in Woldingham, east Surrey, which housed the Czechoslovak military intelligence radio station, was used for communications with the agents during the operation. The assassination attempt was successful, however German reprisals were brutal. Thousands of Czechs were killed in retaliation. The SOE agents were eventually surrounded in a church in Prague and were killed or took their own lives to avoid capture.

Winterfold House in Cranleigh was used as a SOE centre for evaluation, selection and initial training of new recruits. It was here that Violette Szabo arrived in August 1943 at the age of twenty-one. After completing her training, she was sent to France where she was captured and executed in February 1945 at Ravensbrück concentration camp. Her body was never recovered. She was posthumously awarded the George Cross and Croix de Guerre. Her name appears on a memorial in Brookwood Military Cemetery.

Another of Szabo's SOE contemporaries was also held in Ravensbrück and although sentenced to death, she did survive the war. Odette Sansom was one of the first women to be recruited into the organisation. Sansom received the George Cross and was made an MBE. She retired, with her third husband, to Elmbridge in the 1980s. She died in 1995 and was buried in Burvale Cemetery, Hersham.

Mystery surrounds the fate of one of Surrey's famous residents during wartime. The British actor Leslie Howard moved into Stowe Maries in Westcott, west of Dorking, with his family in 1930. In 1943, he was travelling on a commercial flight from Lisbon to London. Since Portugal was a neutral country, the flight should have been safe. Yet it was shot down by enemy aircraft with all passengers lost. Speculation was rife that Howard was targeted because of his propaganda work for the British government or that he might have even been a secret agent.

The onset of war resulted in several of the county's hospitals becoming part of the centralised government-run Emergency Hospital Service. Botleys Park Mental Hospital in Chertsey became an emergency war hospital with 800 beds, treating both military and civilian casualties. In 1944, the hospital was turned into a first-line hospital, receiving casualties from the Normandy invasion before they were sent on to other locations for recuperation.

In August 1939, the Horton Asylum in Epsom was evacuated when psychiatric patients were transported by a fleet of London Transport buses to other local hospitals. Residents were asked to provide accommodation for the hundreds of doctors and nurses brought down from London to staff the hospital.

Banstead Hospital became an emergency war hospital in 1940, then a military hospital for service personnel suffering from mental disorder. Other hospitals in Surrey that came under the emergency service were at Caterham, Cobham and East Surrey Hospital at Redhill. The Emergency Hospital Service was the first time that hospitals had come under the control of the state, a precursor to the formation of the National Health Service in 1948.

It was on the evening of 7 May 1945 that Surrey residents heard, like those throughout the land, that the war in Europe had come to an end. The following day, VE day, was designated a national holiday. The day was celebrated with street parties, bunting and flags. In the evening the sound of fireworks filled the air, the *Surrey Mirror* reporting that 'bonfires sprang to life as dusk fell, and at most of them effigies of Adolf Hitler, the most hated man in Europe, were committed to the flames'. Large numbers caught trains into London to participate in festivities there. Thanksgiving services were held in most churches in the county. Residents stopped to listen to the radio at 9 p.m. that evening as the king addressed the nation, reminding all of the sacrifices made: 'Let us remember

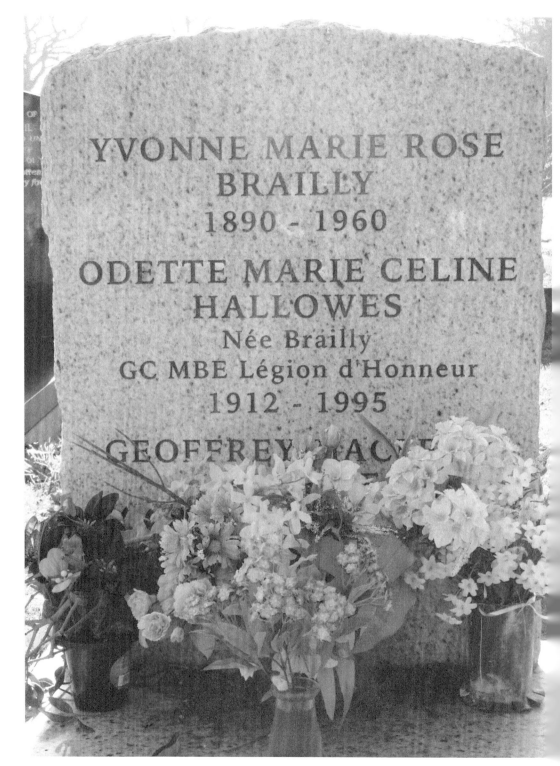

The grave of Odette Sansom in Burvale Cemetery.

A wounded soldier outside Horton Hospital. (Copyright Bourne Hall Museum)

those who will not come back, their constancy and courage in battle, their sacrifice and endurance in the face of a merciless enemy.'

Brookwood Military Cemetery, west of Woking, is the largest Commonwealth War Graves Commission site in the United Kingdom. It contains the graves of 3,470 service personnel from the British Empire who died in this country or in surrounding seas during the Second World War, of which 2,400 were Canadians. Sections of the cemetery are dedicated to Belgian, Czech, French, German, Italian and Polish war graves. Some 3,500 who fell during the conflict but have no known graves are commemorated in a Second World War memorial.

The Canadian section of Brookwood Military Cemetery.

A tribute at Brookwood to the Czechs who lost their lives during the war.

A German aircrew buried at Brookwood.

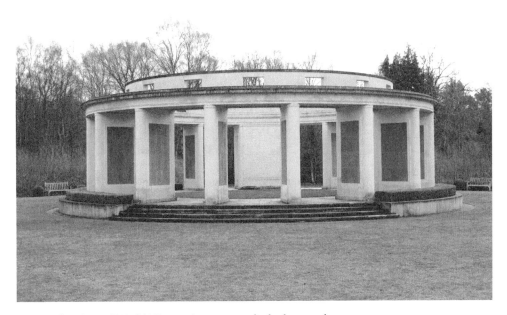

Memorial to Second World War service personnel who have no known grave.

# 7. Surrey Regiments

The Cardwell army reforms of the 1870s and 1880s led to significant modernising of the British Army. Regiments were reorganised, which led to the formation of the Queen's Royal Regiment (West Surrey) and the East Surrey Regiment in 1881. Since then, the two regiments have served all over the world, through countless campaigns. It would be an impossible task to cover all of their achievements and engagements in detail here. At risk of omitting many of their valiant endeavours, some of their many notable operations are described below.

The Queen's Royal Regiment (West Surrey) can lay claim to be England's oldest infantry regiment, tracing its origins back to 1661 when Charles II raised the Tangiers Regiment to defend the British possession in North Africa against the Moors. After the regiment had returned to England in 1684, it became known as the Queen's Royal Regiment and one year later fought at the Battle of Sedgemoor, considered to be the last battle on English soil, defeating an attempt to overthrow James II.

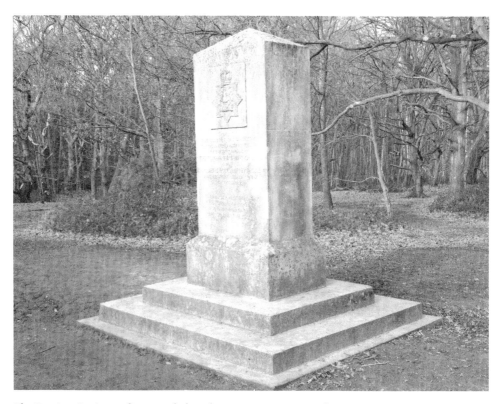

The Tangiers Regiment first paraded on this spot on Putney Heath in 1661.

The regiment fought in the Peninsular War in Portugal and Spain from 1808 to 1814. Initially unsuccessful, the British had withdrawn from Spain in 1809. The regiment returned to Portugal in 1811 and, as part of the British Army under the Duke of Wellington, were in action at Salamanca, Vittoria and in the Pyrenees. Wellington succeeded in taking Toulouse, the war ending with Napoleon's abdication in 1814. The regiment went on to serve in China in 1860 during the Second Opium War, in Burma and on the North West Frontier in India.

Following its inauguration in 1881, the Queen's Royal Regiment (West Surrey) fought in the Boer War, the 2nd Battalion spending four and a half years in South Africa. Lieutenant Wallace Duffield Wright was the first soldier from the regiment to be awarded the Victoria Cross for leading his men against superior numbers during the Kano-Sokoto expedition in northern Nigeria.

At the beginning of the First World War, the 1st Battalion arrived at Le Havre as part of the British Expeditionary Force, followed shortly after by the 2nd Battalion who landed at Zeebrugge in Belgium. Both were to suffer heavy casualties. The 1st went straight into action on 23 August 1914 at Mons in Belgium, one of the first major engagements of the war. The Allies suffered a heavy defeat followed by a retreat, covering 136 miles in thirteen days, to the River Marne just north of Paris. It was at the Battle of the Marne that the French and British armies won their first victory against the Germans and saved Paris from capture. By November 1914, the 1st had only thirty-two survivors. Having received reinforcements, the 1st went on to fight at Ypres and the Somme. The 2nd Battalion also saw action at Ypres, the Somme and Passchendaele.

In November 1917, the men of the 2nd were en route to Italy. Initially aligned with Germany and Austria-Hungary in the Triple Alliance, Italy sided with Britain and France in 1915, declaring war on Austria-Hungary and subsequently Germany. The Italians were to suffer a heavy defeat at the Battle of Caporetto in 1917 after which they were forced back to just north of Venice, with 11,000 dead and over 250,000 captured. Alarmed by this defeat, the British and French sent reinforcements to Italy. In October 1918, the 2nd fought alongside the Italian army in a decisive victory against Austria-Hungary at the Battle of Vittorio Veneto.

Realising that the regular army needed support, Kitchener, the Secretary of State for War, launched a campaign to recruit volunteers. The Queen's was strengthened in August and September 1914 by the formation at Guildford of the 6th, 7th and 8th Battalions. The 6th was one of the first of Kitchener's new armies and after training was sent to France in June 1915. They fought at the battles of Loos, Somme, Arras and Cambrai. The 7th arrived in France at the same time suffering heavily at Arras and the Third Battle of Ypres. The 8th were also present at Loos, Somme and Ypres. During the First World War, the Queen's Royal Regiment (West Surrey) would lose a total of 8,000 men. Four Victoria Crosses were awarded to men from the regiment.

At the beginning of the Second World War, it was the territorial battalions who were the first from the Queen's Regiment to see action in France, arriving in April 1940. The 5th, 6th and 7th Battalions increased in number and each unit was divided into first- and second-line battalions.

The first-line battalions – the 1st/5th, 1st/6th and 1st/7th – were part of the British Expeditionary Force, resisting valiantly in an attempt to hold up the Germans on the French border with Belgium. Forced back, they were evacuated from Dunkirk in May 1940.

SACRED TO THE MEMORY
OF THE OFFICERS, N.C. OFFICERS AND MEN
OF THE 2ND BATT. THE QUEEN'S REGT.
WHO FELL OR DIED DURING THE SOUTH AFRICAN WAR 1899-1902.
ERECTED BY THEIR COMRADES OF BOTH BATTALIONS.

### KILLED IN ACTION.

| | | | | | | | | |
|---|---|---|---|---|---|---|---|---|
| 3837 | CPL. J.P.CRONIN. | 15.12.99. | MAJOR | D.MACKWORTH.I'B" | 6.1.00. | 2944 | PTE. W.LEZEMORE. | 23.2.00. |
| 5283 | " J.WELSFORD. | 27.2.01. | 3271 | PTE. A.GANDER. | 18.2.00. | 4602 | " W.MUNDAY. | 23.2.00. |
| 2873 | PTE. J.ALLEN. | 18.2.00. | 5497 | " G.HIDER. | 11.6.00. | 4157 | " G.STEBBINGS. | 23.2.00. |
| 2299 | " J.ARCHER. | 15.12.99. | 4139 | " C.JONES. | 23.2.00. | 3026 | " E.STEVENS. | 21.1.00. |
| 3104 | " C.AUSTIN. | 15.12.99. | 3206 | " J.JUKES. | 18.2.00. | 3090 | " F.WILLIAMS. | 18.2.00. |
| 2936 | " H.BURSEY. | 21.1.00. | 5531 | " W.HALL. | 14.6.01. | 5460 | " J.TIMSON. | 27.2.01. |
| | | | 5699 | " F.O'BRIEN. | 5.9.01. | | | |

### DIED OF WOUNDS RECEIVED IN ACTION.

| | | | | | | | | |
|---|---|---|---|---|---|---|---|---|
| 3283 | SERGT.J.ELLIS, | 15.12.99. | CAPTAIN | A.D.RAITT. | 21.1.00. | 2545 | PTE. C.DONALDSON. | 26.2.00. |
| 2129 | LCESGT.J.HARMON. | 15.12.99. | LIEUT. | B.H.HASTIE. | 23.2.00. | 5775 | " F.DOWDING. | 14.6.00. |
| 5574 | CPL. S.HANNAY. | 18.2.00. | 2ND LIEUT. | C.S.DU BUISSON, | 2.4.00. | 3558 | " J.P.GALLIE. | 16.12.99. |
| 5544 | LCECPL.W.DUNN. | 25.2.00. | 3353 | PTE.H.BENNING. | 21.1.00. | 2833 | " W.GODDARD. | 15.12.99. |
| 3246 | " G.HILLIER. | 15.12.99. | 3112 | " T.CAPELL. | 15.12.99. | 3093 | " A.NEW. | 15.12.99. |
| 5129 | PTE.J.PETERS. | 7.2.00. | 3499 | " E.DAWSON. | 21.1.00. | 2894 | " H.ROBERTS. | 21.1.00. |
| 3209 | " W.HANDS. | 21.1.00. | 4996 | " G.HARRIS. | 7.2.00. | 2998 | " W.STUBBERFIELD,19.12.99. |

### DIED OF DISEASE.

| | | | | | | | | |
|---|---|---|---|---|---|---|---|---|
| 7373 | PTE. R.BURROWS, | 30.4.00. | LIEUT. | G.W.POYNDER. | 18.2.02. | 4221 | PTE. J.HANLEY. | 21.7.00. |
| 2367 | " J.BARGE, | 9.5.00. | 517 | QRMR SGT.E.KILPATRICK. | 26.1.02. | 1497 | " C.J.KEEN. | 20.11.00. |
| 5735 | " D.BARNES. | 19.5.00. | 4894 | SERGT.C.STREET. | 26.4.00. | 2746 | " A.KING. | 11.8.00. |
| 5698 | " W.BEVAN. | 5.5.00. | 5159 | " W.SIMMONDS. | 11.2.01. | 3186 | " F.LITTLE. | 27.4.00. |
| 5447 | " G.COLLIS. | 28.3.00. | 3356 | LCESGT.W.HUMBERSTONE.29.4.00. | | 5716 | " J.LAMPORT. | 18.5.00. |
| 7320 | " A.FOSBERRY. | 6.7.00. | 2648 | LCECPL.A.SHOVE. | 8.5.00. | 2421 | " J.LAY. | 28.2.00. |
| 3077 | " H.HALL. | 6.8.00. | 2664 | " A.BURFIELD. | 11.6.00. | 2665 | " A.MARSHALL. | |
| 7388 | " F.PIKE. | 24.6.00. | 2418 | " C.S.PITTS. | 15.11.00. | 2727 | " W.MAIN. | 18.6.00. |
| 2188 | " G.PRATT. | 11.6.00. | 4068 | " M.REGAN. | 7.7.00. | 5745 | " T.MITCHELL. | 14.5.00. |
| 5556 | " W.ROGERS. | 20.5.00. | 5505 | " E.THACKER. | 14.4.00. | 4958 | " E.NEVILLE. | 24.11.00. |
| 3002 | " T.ROGERS. | 30.8.00. | 6180 | " W.LESTER. | 16.12.01. | 5788 | " J.STEARMAN. | 23.7.00. |
| 2198 | " W.SEYMOUR. | 21.3.00. | 6044 | " J.SHEEHAN. | | 5834 | " A.TYLER. | 15.5.00. |
| 3068 | " J.SCREECH. | 18.4.00. | 2638 | CPL.H.GROVER. | 19.6.01. | 5631 | " P.WARD. | 19.5.00. |
| 5848 | " A.SMITH. | 12.6.00. | 5636 | PTE.F.ROBERTS. | 25.4.00. | 2260 | " E.WASSELL. | 2.4.00. |
| 4149 | " W.MURDIN. | 30.5.00. | 1290 | " J.MARNEY. | 22.12.00. | 6179 | " J.SHELVEY. | 2.1.01. |
| 2949 | " H.BAKER. | 24.1.01. | 2959 | " C.DAVIS. | 30.12.00. | 6261 | " C.PITHER. | 19.1.01. |
| 5956 | " F.JONES. | 9.2.01. | 4540 | " A.YEELES. | 30.4.01 | 3219 | " W.RUSSELL. | 18.6.01. |
| 3079 | " A.POTTER. | 13.2.01. | 4216 | " R.STEVENS. | 27.5.01. | 6254 | " B.GEORGE. | 7.7.01. |
| 1592 | " J.CONNELL. | 18.2.01. | 5230 | " S.WRIGHT. | 29.5.01. | 6432 | " E.ELLIS. | 30.7.01. |
| 3118 | " O.CHIPPING. | 9.3.01. | 5071 | " J.SAUNDERS. | 1.6.01. | 4616 | " C.FRANCIS. | 4.10.01. |
| 1453 | " J.MAHERS. | 21.3.01. | 5923 | " F.WILLS. | 13.6.01. | 6173 | " J.RAYNER. | 9.11.01. |
| 2633 | " J.GREENER. | 12.1.02. | 5972 | " W.SHARPE. | 25.11.01. | 5830 | " M.GRAVITT. | 10.2.02. |
| 3085 | " E.BIRD. | 14.1.02. | 6000 | " W.WELLS. | 29.11.01. | 6438 | " T.CARROLL. | 17.2.02. |
| 6020 | " G.OVENDEN. | 18.1.02. | 6302 | " T.FEEY. | 5.12.01. | 6444 | " A.SMITH. | 13.3.02. |
| 2906 | " H.ISLES. | 3.1.02. | 1407 | " C.COOK. | 17.12.01. | 3458 | " J.JORDAN. | 18.3.02. |
| 5087 | " C.DENYER. | 19.1.02. | 6367 | " A.CLIST. | 11.1.02. | 6813 | " H.GRAY. | 22.3.02. |
| 5456 | " E.PLUMMER. | 10.1.02. | 4816 | " J.SALMON. | 7.2.02. | 5823 | " A.NASH. | 23.3.02. |
| 6270 | " L.SMITH. | 27.1.02. | 6172 | " P.MASSEY. | 18.4.02. | 2895 | " W.GIBBON. | 6.4.02. |
| 7554 | " C.SNELLING. | 30.4.02. | 6224 | " J.CONNOR. | 17.4.02. | 6232 | " H.PRIKE. | 6.4.02. |
| 6053 | " C.PALER. | 6.5.02. | 7547 | " H.ELLIS. | 27.4.02. | 5518 | DR. G.YEELES. | 14.3.02. |
| 5743 | " W.KING. | | 4836 | " W.COLLINGWOOD,13.2.01. | | 5836 | PTE.G.HOWARD. | |
| 3682 | " G.CHILDS. | 2.6.02. | 2328 | " H.SMITH. | | 5052 | " G.CLARKE. | 12.5.02. |
| 6550 | " J.ENGLISH. | 30.6.02. | LIEUT. | L.D.WEDD.D.S.O. | 7.7.02. | 5684 | " G.HILLYARD. | 26.6.02. |

"PRISTINÆ VIRTUTIS MEMOR."
"VEL EXUVIÆ TRIUMPHANT."

The Queen's (West Surrey) Boer War memorial in Holy Trinity Church, Guildford.

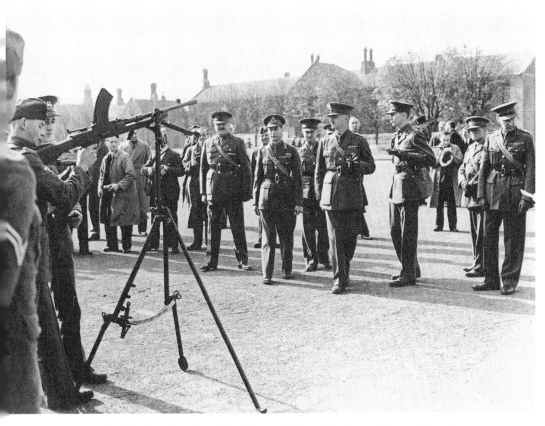

George VI visiting the Queen's at Stoughton in 1939. (Copyright Surrey History Centre)

The second-line battalions – the 2nd/5th, 2nd/6th and 2nd/7th – fought at Abbeville, on the French coast. Lacking sufficient armaments, they were overrun, retreating to Rouen and were eventually evacuated from Cherbourg. The territorial battalions had lost many men during the Battle of France and were reformed and rearmed back in Britain.

In 1942, the 1st/5th, 1st/6th and 1st/7th joined up with the Eighth Army under Montgomery in North Africa and fought in the Battle of El Alamein. They then joined the 7th Armoured Division, known as the famous 'Desert Rats'. After participating in the invasion of Italy, the troops returned to Britain in January 1944 in preparation for the Normandy invasion. They arrived in France two days after D-Day, fought at Caen and then pushed on into Belgium and the Netherlands. The 1st/5th continued into northern Germany, arriving at Hamburg, a city in ruins as a result of heavy Allied bombing.

The 2nd/5th, 2nd/6th and 2nd/7th left for Iraq in August 1942 where they underwent intensive training. In March 1943 they received orders to leave for Egypt by road and then on to Tunisia where they joined the Eighth Army. They had covered 3,313 miles in one month, yet on arrival there was no respite. The following day they went into battle south of Tunis. In September 1943 the three battalions became part of an Anglo-American force of 70,000 men that launched the invasion of mainland Italy, landing at Salerno.

While the territorial battalions were fully engaged in various campaigns in Europe and North Africa, the 1st and 2nd Battalions were called into action against the Japanese. After taking Burma, the Japanese launched a major offensive on north-east India in March 1944. At Kohima, a small contingent of Anglo-Indian troops, including men from the Queen's Own Royal West Kent Regiment, had been under siege by the Japanese for two weeks. The 1st, together with Ghurkha and Indian troops, were able to relieve the siege after fierce hand-to-hand combat. The Battle of Kohima was one of the turning points in the campaign against the Japanese.

Initially located in the Middle East, the 2nd Battalion went to Ceylon in March 1942 and then on to India. It was there that the men were transferred to a special force, known as the 'Chindits', made up of British, Indian and African infantry. Their mission: to go deep into the Burmese jungle using guerrilla-like tactics in enemy territory. Once training had been completed, the special force set off in February 1944. The target was to take Indaw, northern Burma. Marching through jungle in torrential rain, using mules and ponies, receiving supplies from intermittent and inaccurate air drops, the special force had covered 110 miles by the end of February. On reaching Indaw, the attack was repulsed by the Japanese. Short of water, the men were ordered to return to India where they stayed in a rest camp. Many were suffering from tropical diseases. All told, they had spent ninety-four days in Burma and covered 575 miles.

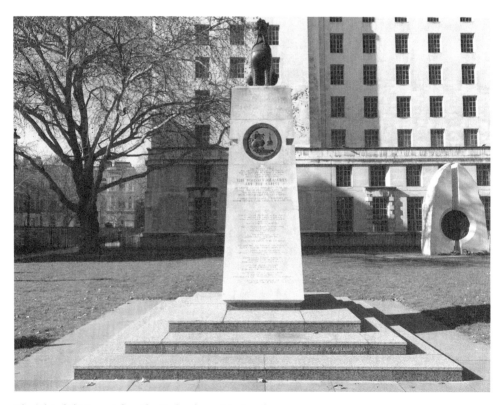

The 'Chindit' Memorial on the Embankment in London.

THE FOLLOWING TOOK PART IN
THE CHINDIT CAMPAIGNS 1943-1944

45 RECONNAISSANCE REGIMENT RAC
ROYAL REGIMENT OF ARTILLERY
CORPS OF ROYAL ENGINEERS
ROYAL CORPS OF SIGNALS
2BN THE QUEEN'S ROYAL REGIMENT (WEST SURREY)
2BN THE KINGS OWN ROYAL REGIMENT (LANCASTER)
1BN THE KINGS REGIMENT (LIVERPOOL)
13BN THE KINGS REGIMENT (LIVERPOOL)
1BN THE BEDFORDSHIRE & HERTFORDSHIRE REGIMENT
2BN THE LEICESTERSHIRE REGIMENT
7BN THE LEICESTERSHIRE REGIMENT
1BN THE LANCASHIRE FUSILIERS
1BN THE CAMERONIANS (SCOTTISH RIFLES)
2BN THE DUKE OF WELLINGTON'S REGIMENT
(WEST RIDING)
4BN THE BORDER REGIMENT
1BN THE SOUTH STAFFORDSHIRE REGIMENT
2BN THE BLACK WATCH (ROYAL HIGHLAND REGIMENT)
1BN THE ESSEX REGIMENT
2BN THE YORK & LANCASTER REGIMENT
142 COMMANDO COMPANY
ROYAL ARMY CHAPLAINS DEPARTMENT

The Queen's (West Surrey), one of the regiments in the 'Chindit' campaign.

It was for his brave actions in Burma during 1944, while attached to the Northamptonshire Regiment, that Lieutenant Alec Horwood from the Queen's was posthumously awarded the Victoria Cross for leading his men in an attack against the enemy. The *London Gazette* reported: 'The cool, calculated actions of this officer, coupled with his magnificent bearing and bravery which culminated in his death on the enemy wire, very largely contributed to the ultimate success of the operation which resulted in the capture of the position on the 24th January.'

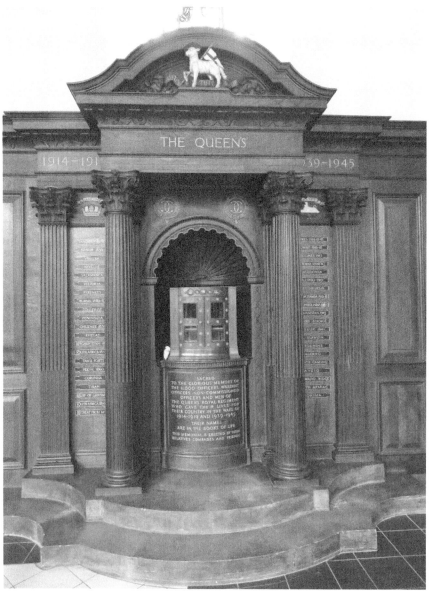

In memory of those from the Queen's (West Surrey) who died in the two world wars.

The Queen's (West Surrey) regimental chapel in Holy Trinity Church, Guildford.

The 2nd Battalion was present in Berlin following Germany's surrender, caught up in the Berlin blockade, before being disbanded in September 1948. The 1st Battalion, mainly consisting of national service conscripts, could be found in 1954 in the Far East in action against communist guerrillas in the Malayan jungle for the next three years.

The East Surrey Regiment was formed from the 31st (Huntingdonshire) Regiment of Foot, which became the 1st Battalion, and the 70th (Surrey) Regiment of Foot, which became the 2nd Battalion. The 31st Regiment of Foot dates back to 1702 and served during the American War of Independence, fought in the Peninsular War in Spain against Napoleon's army and in the Crimean War. The 70th Regiment of Foot was raised in 1756 serving, like the 31st, during the American War of Independence and Napoleonic Wars. They also fought during the Indian Mutiny in 1857 and in New Zealand against the Maoris from 1861 to 1866.

The first major conflict faced by the newly formed East Surrey Regiment occurred in 1899 when the 2nd Battalion was ordered to South Africa. The British Army was not initially used to the conditions and tactics used during the Boer War and the 2nd was involved in 'Black Week' from 10 to 17 December 1899, during which the British suffered three heavy defeats. At the beginning of 1900, the tide had turned and the 2nd fought in the Battle of Tugela Heights, which led to the relief of Ladysmith in March of that year. It was during the Boer War that the East Surrey Regiment received its first Victoria Cross, which went to Private A. E. Curtis for rescuing a wounded officer under fire.

Memorial to the East Surrey Regiment, All Saints Church, Kingston.

At the outbreak of the First World War, the regiment raised sixteen battalions in addition to the regular 1st and 2nd Battalions. The campaign for recruiting volunteers resulted in thousands of boys coming forward who were below the legal limit of nineteen years of age for combat overseas. One of these, Sidney George Lewis, enlisted in the East Surrey Regiment in August 1915 at the tender age of twelve years and four months. He is thought to have been the youngest soldier to have served in the First World War. Having fought at the Battle of the Somme, he was discharged in 1916 after his mother wrote to the War Office regarding his true age.

The 1st Battalion of the East Surreys was soon to enter active service arriving in Le Havre on 15 August 1914 and was present on the Western Front for most of the war. In the first few months they fought at Mons, the Marne and at Aisne. In the spring of 1915, the 1st fought in a rearguard action in defence of 'Hill 60', just 3 miles outside Ypres in Belgium. The hill was of significant strategic importance since it dominated the surrounding countryside. It was subject to intense artillery bombardment and sustained enemy attack.

During the battle the 1st Battalion received three Victoria Crosses in the space of twenty-four hours from 20 to 21 April 1915. The first was awarded to Private Edward Dyer, who according to the *London Gazette*, 'succeeded in dispersing the enemy by the effective use of his hand grenades' as he tended to wounded colleagues under heavy shellfire. Sixteen months later, Private Dyer was killed at the Battle of the Somme. The second Victoria Cross went to Lieutenant George Roupell, who fought off a German attack even though wounded. The third was awarded to Second Lieutenant Benjamin Handley Geary for repelling a German advance.

The 2nd Battalion, which had been stationed in India, returned to Britain and arrived at the Western Front in January 1915. Four companies from the 2nd were deployed near Ypres where they suffered severe losses. Only 200 soldiers remained out of 1,000. In October 1915 the 2nd was posted to Macedonia and Salonika where they were to come up against the Bulgarian army.

The 8th Battalion took part in the first day of the Battle of the Somme, in what was to go down in military folklore. Captain W. P. Nevill had brought some leather footballs from England. As he led his troops over the top at 7.30 a.m. on 1 July 1916, his company launched the footballs into no man's land. His men kicked and passed the footballs as they made their way towards the German lines under heavy machine-gun fire. The 8th was successful in taking the enemy trenches in spite of significant casualties. Captain Nevill died before he had reached the enemy. He was twenty-one years old. One of the original footballs is on display at the Princess of Wales's Royal Regiment (PWRR) and Queen's Regiment Museum at Dover Castle. Another was held at the Surrey Infantry Museum at Clandon Park in Surrey, but was lost in the fire that destroyed the house in 2015.

Educated at Kingston Grammar School, Captain R. C. Sherriff joined up in November 1915 and obtained a commission with the 9th Battalion of the East Surreys as a second lieutenant. He fought in the battles at Vimy Ridge and Loos, before being wounded at Passchendaele in August 1917. He was sent back to England for treatment, never to return to France. He was demobilised in early 1919. Sherriff went on to write *Journey's End*, a

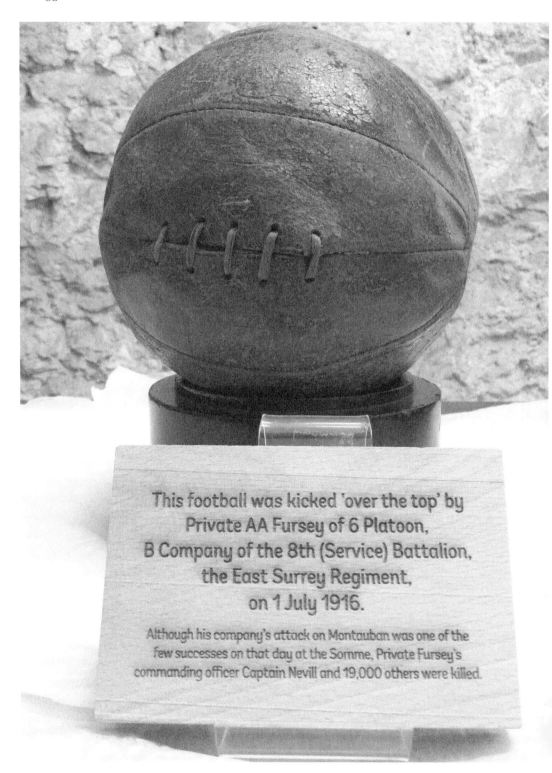

This football was kicked 'over the top' by
Private AA Fursey of 6 Platoon,
B Company of the 8th (Service) Battalion,
the East Surrey Regiment,
on 1 July 1916.

Although his company's attack on Montauban was one of the
few successes on that day at the Somme, Private Fursey's
commanding officer Captain Nevill and 19,000 others were killed.

Remnant from the 'Football Charge'. (Courtesy of PWRR and Queen's Regiment Museum)

play about the horrors of trench warfare based on his own wartime experiences. *Journey's End* was first performed on stage in 1928 to critical acclaim and is still performed to this day, with several film versions based on Sherriff's script.

Over 6,000 men from the East Surreys lost their lives during the First World War and a total of seven Victoria Crosses were awarded to soldiers from the regiment. The Armistice of November 1918 did not, however, put an end to the action.

From August to October 1919, the 1st Battalion was dispatched to Russia at the end of the ill-fated Northern Russian Expedition. Troops from Britain, France and the United States had been sent to support anti-communist forces against the Bolsheviks in June 1918. Opposition to the expedition back home increased and following defeat at the hands of the Bolsheviks, the Allied armies had been withdrawn by October 1919.

Just as in the First World War, the East Surrey Regiment was in the thick of the action in 1939. The 1st Battalion went to France as part of the British Expeditionary Force in October. They were joined by two territorial battalions in April 1940. The 1st and one territorial battalion were evacuated from Dunkirk on 1 June, the second territorial battalion was captured by the advancing German forces.

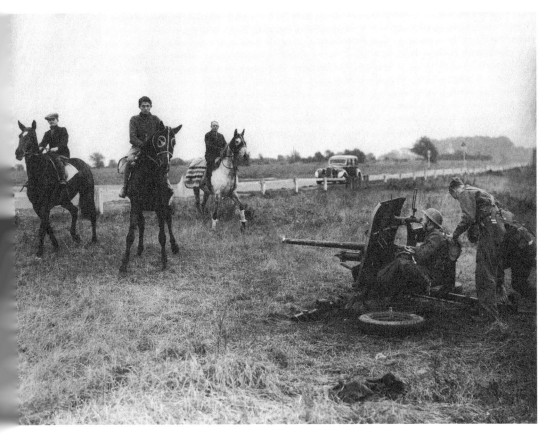

The East Surrey Regiment on Epsom Downs during the Second World War. (Copyright Surrey History Centre)

While the 1st Battalion had been successfully evacuated from Dunkirk, the 2nd Battalion was not so fortunate. The 2nd arrived in Singapore in August 1940, moving up to Jitra in northern Malaya, near the border with Thailand. On 7 December 1941, the Japanese launched a surprise attack on Pearl Harbour and one day later landed on the Malay Peninsula, attacking the 2nd and forcing them south. The battalion suffered heavy casualties, including the capture of their headquarters during which the commanding officer, Major Dowling, and several other officers were killed.

The 2nd had been decimated to such an extent that it could not continue on its own and was combined with the 1st Battalion of the Royal Leicestershire Regiment to form the 'British Battalion'. Facing enemy troops supported by aircraft and tanks, the battalion was eventually ordered to withdraw via Kuala Lumpur to Singapore, arriving on 31 January 1942.

The surviving men of the 2nd had been forced to retreat south over a distance of 400 miles in around fifty days from their original position in north Malay to Singapore in the south. Travelling mainly on foot, sometimes through swamp and jungle, they were pursued by the Japanese. The respite at Singapore would not last long.

Enemy troops landed on Singapore island on 8 February 1942 and, after further resistance, the British forces surrendered to the Japanese seven days later. Winston Churchill was to describe the fall of Singapore as 'the worst disaster and largest capitulation in British history'. Men from the 2nd Battalion were to spend three and a half years in captivity. Conditions were brutal with prisoners forced to work long hours on construction of the Burma railway. Malaria, dysentery and cholera were rife.

The 1st Battalion landed at Algiers in North Africa in November 1942 as part of 'Operation Torch', an Anglo-American operation to invade French North Africa. They were met with relentless German resistance in an attempt to capture Tunis. By the beginning of December, the 1st had lost almost half of their original contingent of 793 men. Plans to take Tunis were put on hold until the following spring, the Germans having occupied and fortified the hills to the west of Tunis controlling the approach to the city. The 1st took part in the final assault that would eventually lead to the German surrender. It was not until May 1943 that the Allied forces eventually captured Tunis, taking over 250,000 German prisoners in the process.

Two months later, the 1st Battalion was in action once more during the invasion of Sicily. Moving across to Italy, both the 1st and the 1/6th Territorial Battalion participated in one of the most hotly contested and longest battles of the Italian campaign. The hills around Cassino provided perfect defensive positions for the Germans overlooking Highway 6, the main route into Rome. The Battle of Monte Cassino lasted from January to May 1944 and it took four separate offenses from the Allies to break through, reaching Rome in June 1944, just two days before D-Day. The German army in Italy surrendered on 2 May 1945.

The East Surrey Regiment lost more than 1,000 men during the Second World War with one Victoria Cross awarded to Lieutenant Eric Charles for resisting several Italian attacks in Africa. In the post-war period the East Surreys served in Greece and Palestine.

The East Surrey Regiment memorial chapel at All Saints Church, Kingston.

The 1st and 2nd Battalions were combined in 1948 and went on to serve in Egypt, Cyprus and Germany.

The East Surrey Regiment and the Queen's Royal Regiment (West Surrey) were amalgamated into the Queen's Royal Surrey Regiment in October 1959, serving in Aden, Hong Kong and Germany. Following a further reorganisation in 1966, the regiments of Surrey, Kent, Sussex and Middlesex combined to form the Queen's Regiment, which in turn became the Princess of Wales's Royal Regiment in 1992. It might appear that Surrey no longer has any direct link with a particular regiment, but the heritage and customs of the Queen's Royal Regiment (West Surrey) and the East Surrey Regiment still live on to this day in the consolidated regiment.

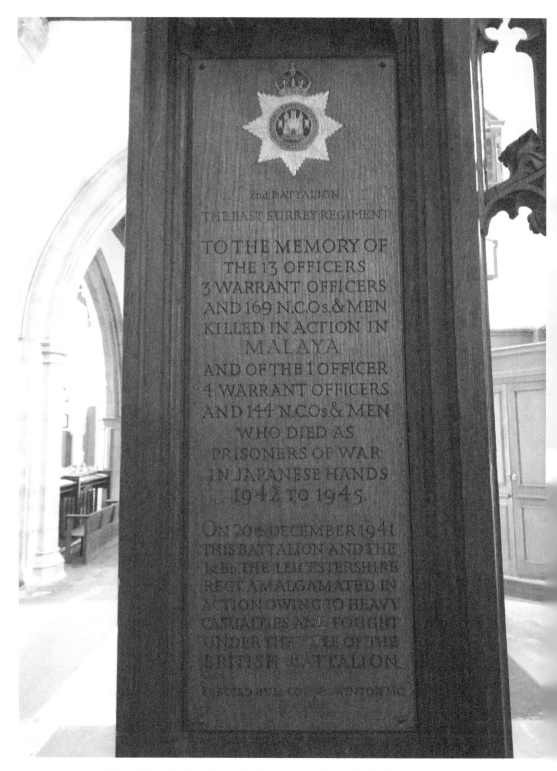

In memory of those from the East Surrey Regiment who died in the Malayan campaign.

The book of remembrance in the East Surrey Regiment memorial chapel.

# Bibliography

Anglo-Saxon Chronicle (translator: James Henry Ingram)

Bird, David, *Roman Surrey* (Stroud: Tempus Publishing Ltd, 2004)

Crook, Paul, *Surrey Home Guard* (Midhurst: Middlehurst Press, 2000)

Essen, R. I., *Epsom's Military Camp* (Epsom: Pullingers Ltd, 1991)

Flower, Stephen, *Raiders Overhead: The Bombing of Walton and Weybridge* (Walton-on-Thames: Air Research Publications, 2004)

Haswell, Jock, *The Queen's Royal Regiment (West Surrey)* (London: Hamish Hamilton Ltd, 1967)

Hearnshaw, F. J. C., *The Place of Surrey in the History of England* (London: MacMillan and Co., 1936)

Janaway, John, *Surrey: A County History* (Newbury: Countryside Books, 1994)

Johnson, Howard, *Wings Over Brooklands* (Weybridge: Whittet Books Ltd, 1981)

Langley, Michael, *The East Surrey Regiment* (London: Leo Cooper Ltd, 1972)

MacDonald, Callum, *The Assassination of Reinhard Heydrich* (Edinburgh: Birlinn Ltd, 2007)

McGinty, Stephen, *Camp Z: How British intelligence Broke Hitler's Deputy* (London: Quercus, 2011)

Ogley, Bob, *Surrey at War 1939–1945* (Westerham: Froglet Publications, 1995)

Malden, H. E., *The Victoria History of the County of Surrey* (London: University of London, 1902–1912)

Pilkington, Len, *Surrey Airfields in the Second World War* (Newbury: Countryside Books, 1997)

Stevens, Phil, *Chobham Common Great Camp 1853* (Camberley: Surrey Heath Local History Club, 2003)

Sweetman, John, *World War II: The Banstead Wood Camp* (Banstead: Banstead History Research Group, 1995)

## Newspapers and Journals

*Illustrated London News*

*London Gazette*

*Surrey Advertiser*

*Surrey Archaeological Archives*

*Surrey Mirror*

## Online Sources

www.brookwoodcemetery.com

www.caterhambarracks.org.uk

www.epsomandewellhistoryexplorer.org.uk

www.exploringsurreyspast.org.uk

www.historicengland.org.uk

www.queensroyalsurreys.org.uk

www.surreyinthegreatwar.org.uk

www.wokinghistory.org

# Acknowledgements

I would like to offer my gratitude to the following organisations for their assistance during my research: Brooklands Museum, Bourne Hall Museum, Chertsey Museum, Dorking Museum, East Surrey Museum, Godalming Museum, PWRR and Queen's Regiment Museum, Queen's Royal Surrey Regimental Association, Surrey Heath Museum, Surrey History Centre and Wings Museum. I would also like to thank Amberley Publishing for their guidance and support in the preparation of this book.